OUTHS WORLD

Copyright © 2019 Publications International, Ltd. All rights reserved. This book may not be reproduced, or quoted in whole or in part by any means whatsoever without written permission from: Louis Weber. CEO Publications International, Ltd. 8140 Lehiah Avenue Morton Grove. IL 60053

Images from NASA, Shutterstock.com, and Wikimedia Commons

CONTENTS

THE VIEW FROM SPACE......

LOOK UP.....

HUBBLE SPACE TELESCOPE	
LIFTOFF	<u></u> 2
THE SPACE SHUTTLE	2
LOOKING AT EARTH	
STEP INTO THE VOID	3
THE INTERNATIONAL SPACE STATION.	3
THE MOON	4
FIRST FOOTPRINT	
MERCURY	4
VENUS	5
MARS	
A RING OF ROCKS	5
JUPITER	
A STORM LARGER THAN EARTH	6
JUPITER'S MANY MOONS	6
SATURN	6
LORD OF THE RINGS	7
SATURN'S MOONS	7
TITAN	
URANUS	8
NEPTUNE	
DWARF PLANETS	8
COMETS	
LANDING ON A COMET	
SHOOTING STARS	
THE SUN	
STARS	
NEUTRON STARS	
THE INTERSTELLAR MEDIUM	
GALAXIES	
THE MILKY WAY GALAXY	14

The mysterious wheeling of tiny brilliant lights in the night sky has been a source of curiosity for as long as humans have walked on Earth. Star maps dating back over 30,000 years have been found drawn on cave walls and carved into bones. Throughout history, major civilizations have created theories to explain the regular cycles of the heavens and the startling bursts and flashes that sometimes seemed to threaten the celestial order. While we can only imagine what our prehistoric ancestors were thinking when they looked up into the night, we know that they felt compelled to create artifacts to record specific astronomical events. Many cultures built structures dedicated solely to the observation of the sky. Others oreated massive stone edifices to mark and measure important phenomena like solstices. Their feats of technological ingenuity still amaze us today.

The earliest known written records deal with astronomical observations. As early as the third millennium BC, Babylonian astronomers were recording their observations of planetary movements. Chinese artifacts dating to the second millennium

BC,recorded eclipses and novas. India's earliest known text on astronomy, the *Vedanga Jyotisha*, dates to about 1400 BC. By the time the Greeks developed it into a branch of mathematics, astronomy was a firmly established discipline in the ancient world. Eudoxus of Cnidus is credited with developing the first three-dimensional model to explain the apparent motion of the planets. The idea that the Earth rotates around its axis originates with the Greeks.

Fascination with the workings of the cosmos has remained constant throughout history. But now for the first time we are able to satisfy our curiosity. Recent decades have seen multiple revolutions in the tools and technology we use to view and understand the universe. Thanks to these advances we are able to see farther and deeper into the sky than ever before.

0.5.54

1226

The Nebra Sky Disc was unearthed from a burial hoard in Germany in 1999.-This 3,600-year-old disc is a kind of astronomical clock, used to harmonize the discrepancy between solar and lunar years. The cluster of seven stars is probably the Pleiades, Researchers believe that Bronze Age astronomers would have added a month to the lunar calendar when the night sky matched the alignments on the disc.

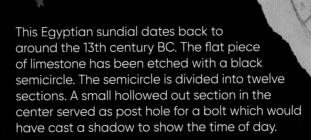

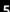

RECORDED IN STONE

The earliest buildings dedicated to astronomical observations were both pragmatic and ritualistic. Communities could plan important annual events like planting, harvesting, and storing by determining the exact dates of the solstices and equinoxes. These celestial cycles were also connected to the belief systems that dealt with life, death, renewal, and growth. Not only were

the first astronomers observers, they were also participants in a cosmic drama. They watched—and encouraged—the return of the Sun in the spring. They tracked the Moon's monthly rounds and worshipped it as well. Stars, wandering planets, streaking comets—all of these astronomical phenomena held vital significance.

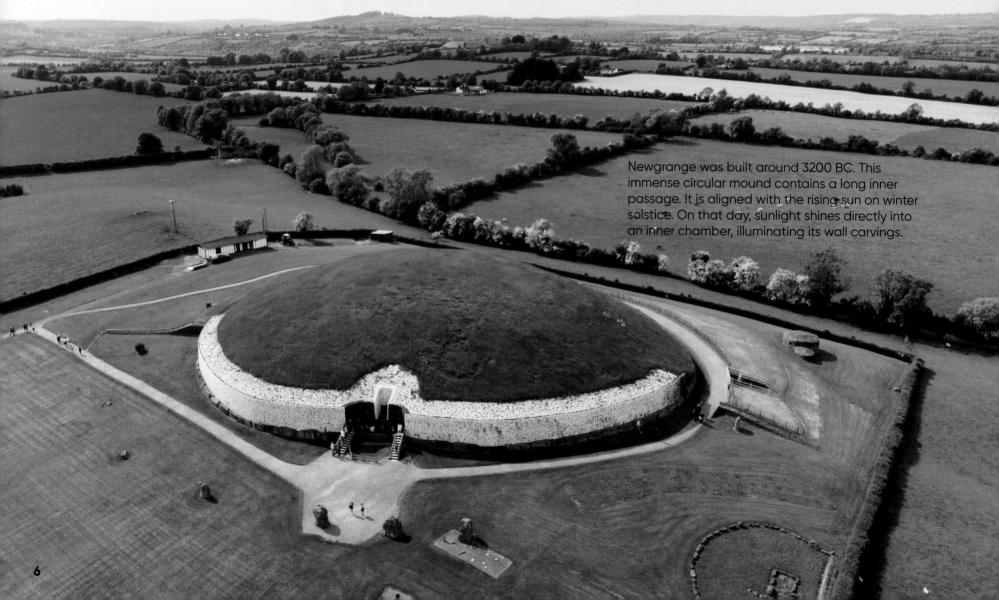

Stonehenge was built in stages, beginning some time in the third millennium BC. It is uncertain whether the site was constructed for astronomical observation. However, the stones clearly mark both the solstices. The winter solstice was probably ritually observed by the monument's builders.

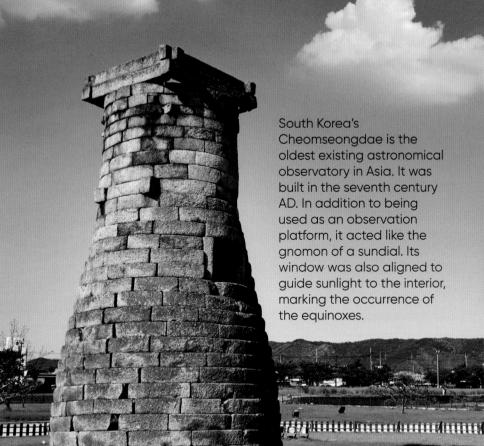

Built around 1000 AD, the pyramidal structure known as El Castillo is set within the ruins of the Mayan city of Chichén Itzá. The pyramid served a number of astronomical functions, but it is now known for an event that occurs twice a year at the equinoxes. At sunset, the gathering shadows give the appearance of a giant snake body undulating down the steps. At the bottom, the shadow body joins with a stone snake head.

Set high in the Andes, Machu Picchu was more than a spectacular example of Incan stoneworking skills. It was also an observatory laid out to allow precise measurements of the sun and other celestial objects. It was built in the fifteenth century.

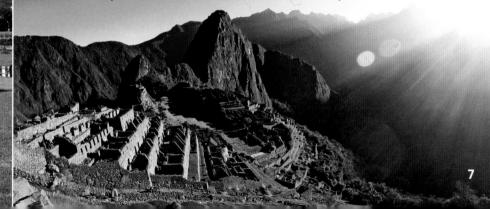

THROUGH MODERN EYES

Astronomy may be a science that has been practiced by people all over the world for thousands of years, but modern, ground-based observatories are unlike anything that has come before. Modern observatories began to take shape several centuries ago. In 1576, Danish astronomer Tycho Brahe established a primitive observatory on a small island off the coast of Sweden. His observatory was responsible for creating a notable compendium of more than 1,000 stars, all catalogued by naked eye. Several decades later, Galileo Galilei devised the first optical telescope. This invention marked a major milestone in the history of astronomical observation.

Optical telescopes were improved throughout the next century. Isaac Newton invented the reflector telescope (a telescope that employs curved mirrors) in 1668. By 1781, William Herschel was using a telescope powerful enough to discover Uranus. By increments, astronomers developed the technology necessary to look farther into the night sky.

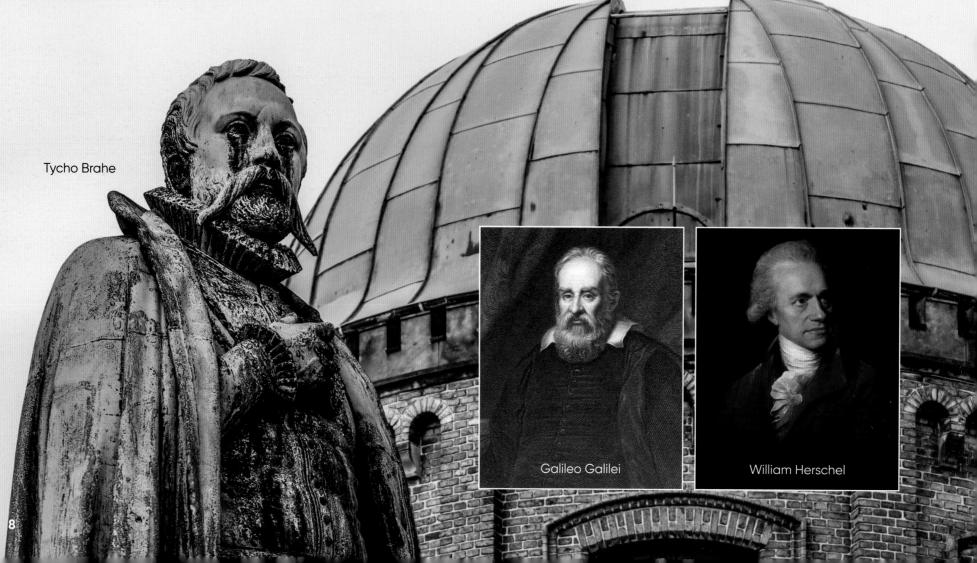

THE 20TH CENTURY

Observatories proliferated around the world in the 20th century, becoming a source of pride to their communities. Facilities like Yerkes Observatory (founded in 1897) represented a recognition of the need for astronomical equipment to be housed with supporting laboratory space. Yerkes was an important center of

research into the nature of globular clusters and the interstellar medium. While most observatories are affiliated with particular institutions, Kitt Peak National Observatory is notable for being open to astronomers across the nation. And Griffith Observatory has been free and open to the public since its opening in 1935.

has been free and open to the public since its opening in 1935. supporting laboratory space. Yerkes was an important center of Location: Williams Bay, Wisconsin Yerkes Observatory is owned by the University of Chicago. The facility is often called "the birthplace of modern astrophysics." Edwin Hubble studied at Yerkes while working on his doctorate. The observatory closed its doors in 2018.

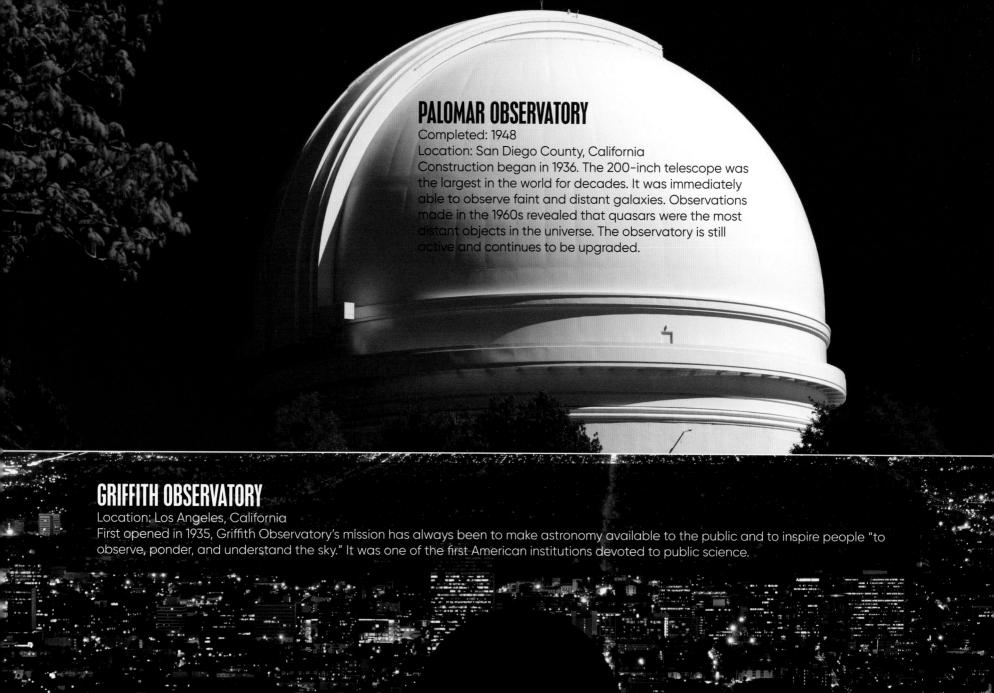

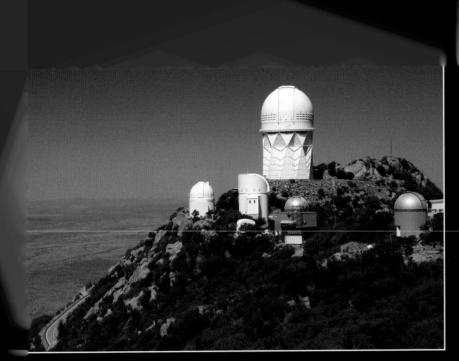

KITT PEAK NATIONAL OBSERVATORY

Completed: First observations in 1964
Location: Schuk Toak District (outside Tucson), Arizona
Kitt Peak is part of the National Optical Astronomy Observatory, one of the largest collections of observatories in the northern hemisphere. The observatory functions as a national center for optical astronomy.

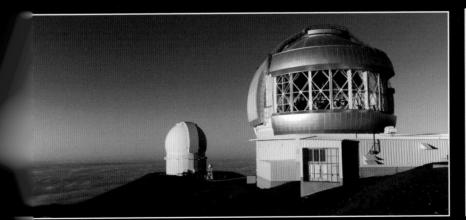

MAUNA KEA OBSERVATORIES

_ocation: Summit of Mauna Kea, Hawaii

The site of this major collection of telescopes and research facilities was irst used for astronomical observations in 1964. The collection includes hree large reflectors, several submillimeter-wavelength telescopes, a radio astronomy facility, and the multimirror Keck telescope. The Keck is

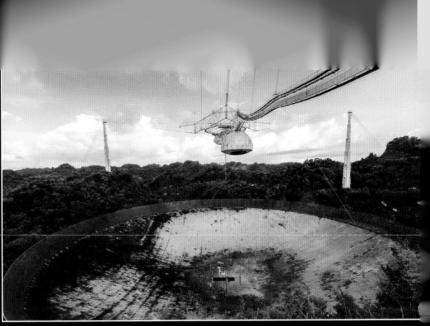

THE ARECIBO OBSERVATORY

Completed: 1963

Location: Arecibo, Puerto Rico

This massive radio telescope is used for research in radio and radar astronomy as well as atmospheric science. Arecibo's long list of achievements includes finding ice at the poles of Mercury, mapping the surface of Venus, pinpointing the rotation rate of Mercury, and discovering the first binary pulsar. And in 1992 it discovered the very first exoplanet.

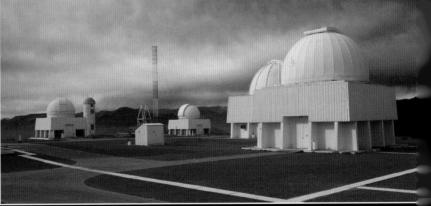

CERRO TOLOLO INTER-AMERICAN OBSERVATORY

Completed: First observations in 1965

Location: Coquimbo Region, northern Chile

This complex of telescopes and instruments is notable for its observations of the central Milky Way and the Magellanic Clouds. In 2017 a team of researchers working at CTIO discovered 12 new moons

THE VERY LARGE ARRAY

Completed: 1980

Location: Soccorro, New Mexico

The Very Large Array consists of 27 radio antennas shaped in a Y configuration. One of the most important radio observatories in the world, the VLA is truly multipurpose. It is capable of looking into the shrouded center of the Milky Way, seeing radio atmospheres around stars, pinpointing plasma ejections from supermassive black holes, and tracking spacecraft in our solar system.

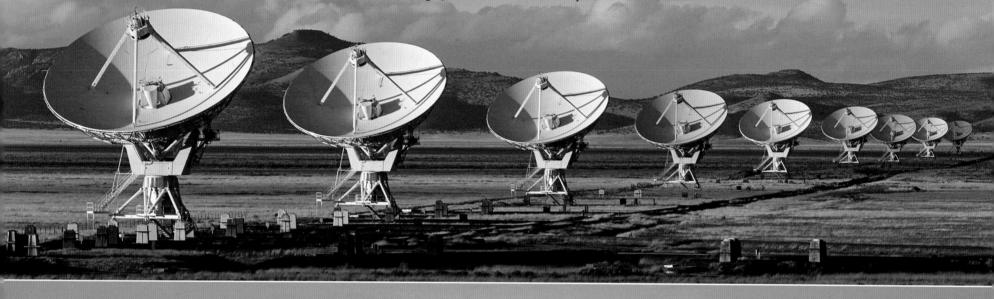

ROQUE DE LOS MUCHACHOS OBSERVATORY

Completed: 1985

Location: Canary Islands

The Roque de los Muchachos Observatory sits atop a mountain on the island of La Palma. The observatory has one of the largest and most extensive suites of telescopes and laboratories in the world. Discoveries and observations include the formation of stars and galaxies early in the universe's history, disintegrating comets, and evidence of exoplanets.

THE VERY LARGE TELESCOPE

Completed: First observations in 1998 Location: Cerro Paranal, northern Chile

The Very Large Telescope consists of eight separate telescopes that can function individually or together. Among other feats, it has tracked individual stars moving around the black hole at the center of our galaxy, observed the afterglow of the furthest known gamma-ray burst, and captured the first visual image of an exoplanet.

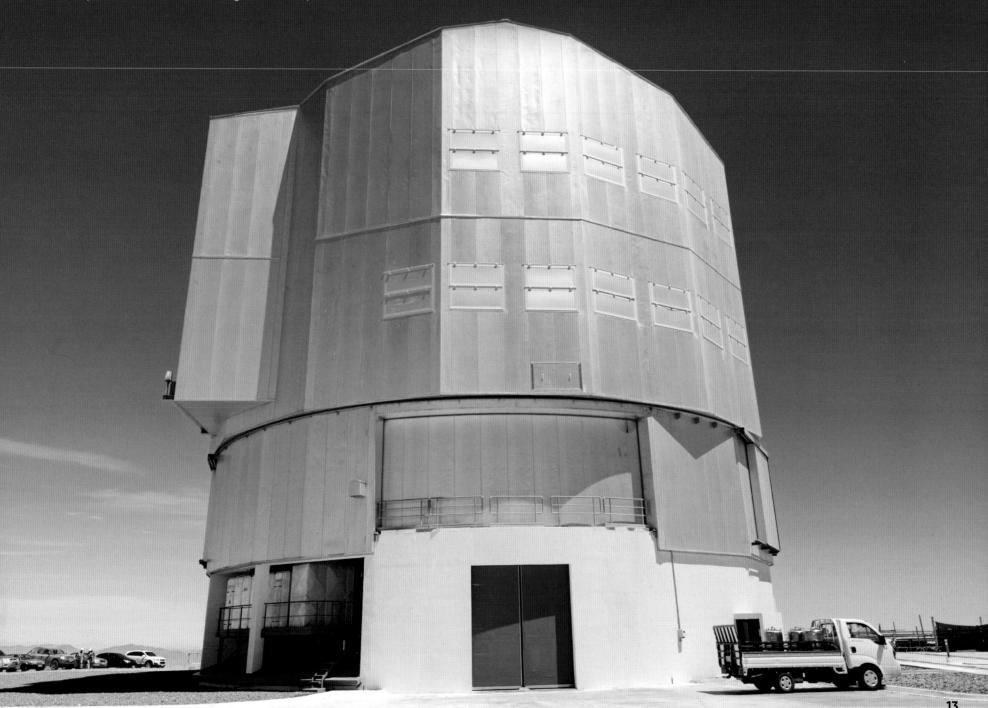

THE VIEW FROM SPACE

Space-based observatories represent another leap forward for astronomy. These observatories avoid some of the problems ground-based observatories encounter, such as light pollution. Great Britain launched the first astronomical satellite (Ariel 1) in 1962. NASA launched its first group of space observatories between 1966 and 1972. These four satellites, known collectively

as the Orbiting Astronomical Observatory (OAO), helped convince the scientific community of the benefits of observing the cosmos above the Earth's atmosphere. The OAO program was a precursor to later observatories like the Hubble Space Telescope. A large number of the images shown in this book come from space observatories.

CHANDRA X-RAY OBSERVATORY

Launched: via space shuttle, 1999 Chandra focuses on the X-ray segment of the electromagnetic spectrum. It observes black holes, quasars, supernovas and hightemperature gases. Chandra's images are 25 times sharper than those of the best previous X-ray telescope.

SPITZER SPACE TELESCOPE

Launched: 2003

Spitzer focuses on the infrared segment of the electromagnetic spectrum. Spitzer is especially important because the Earth's atmosphere blocks most of the infrared radiation originating in outer space. Spitzer is helpful in studying cooler interstellar objects too dim to be detected via visible light. Since infrared light can penetrate clouds of gas and dust, Spitzer is able to see through them into centers of galaxies and newly forming solar systems.

Launched: 2003

The purpose of GALEX was to make observations of star formations in the ultraviolet spectrum. It also took distance measurements of hundreds of thousands of galaxies. These observations spanned 10 billion years of cosmic history. GALEX contributed to our understanding of the basic structures of the universe. It was decommissioned in 2013.

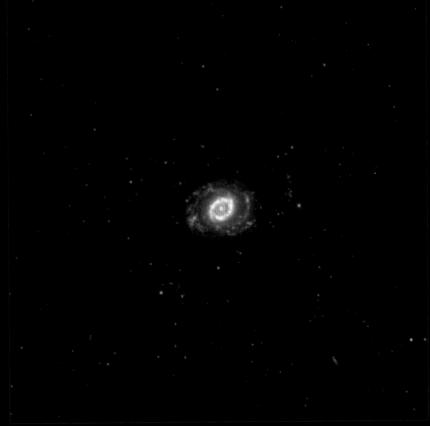

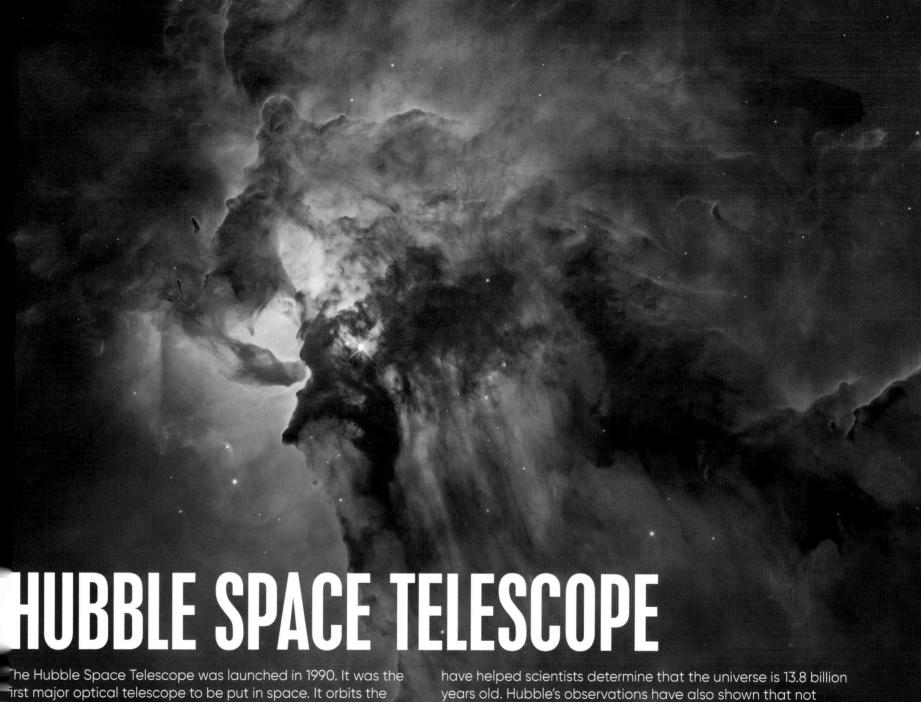

The Hubble Space Telescope was launched in 1990. It was the first major optical telescope to be put in space. It orbits the Earth 340 miles above the surface. With this unobstructed view, t has taken some of the most spectacular images of the cosmos numans have ever seen.

Hubble makes observations in visible, infrared, and ultraviolet iaht. Its cameras and spectrographs catch light that has been

have helped scientists determine that the universe is 13.8 billion years old. Hubble's observations have also shown that not only is the universe expanding, but that its expansion rate is accelerating. The telescope also makes observations closer to home: astronomers have scanned the asteroid belt to discover evidence of collisions, discovered four new moons orbiting Pluto, and revealed a number of mysterious planet-like objects and moons lurking deep in the Kuiper belt.

To get there, you need thrust—lots of it. NASA's Mercury project used Redstone and Atlas rockets. These rockets used ethyl alcohol fuel. The massive Saturn V rockets that shot astronauts to the Moon used different kinds of fuel for different boost stages. Kerosene, liquid oxygen (as an oxidizer), and liquid hydrogen were all used to supply thrust. These fuels continue to be used in modern rockets. The spectacular thrust accomplished in liftoffs also yields some spectacular visuals.

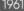

The first manned spacecraft is launched from Cape Canaveral. The Mercury-Redstone 3 (Freedom 7) was piloted by astronaut Alan Shepard.

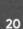

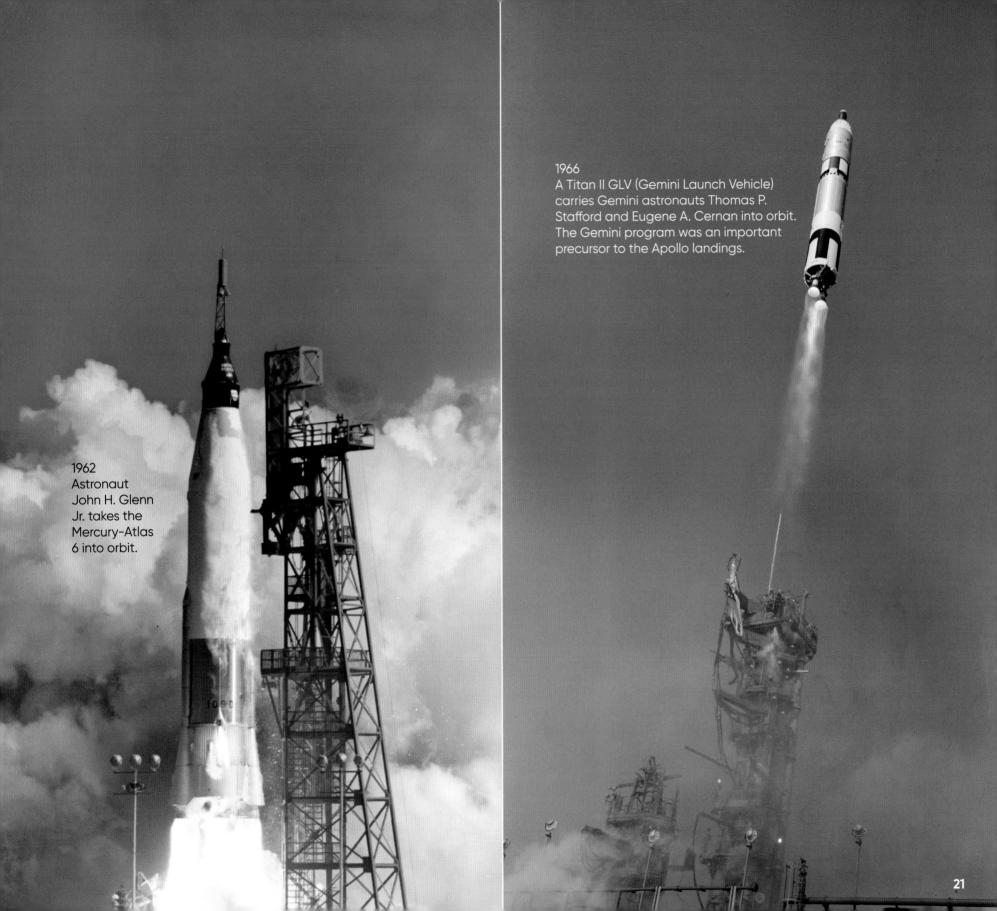

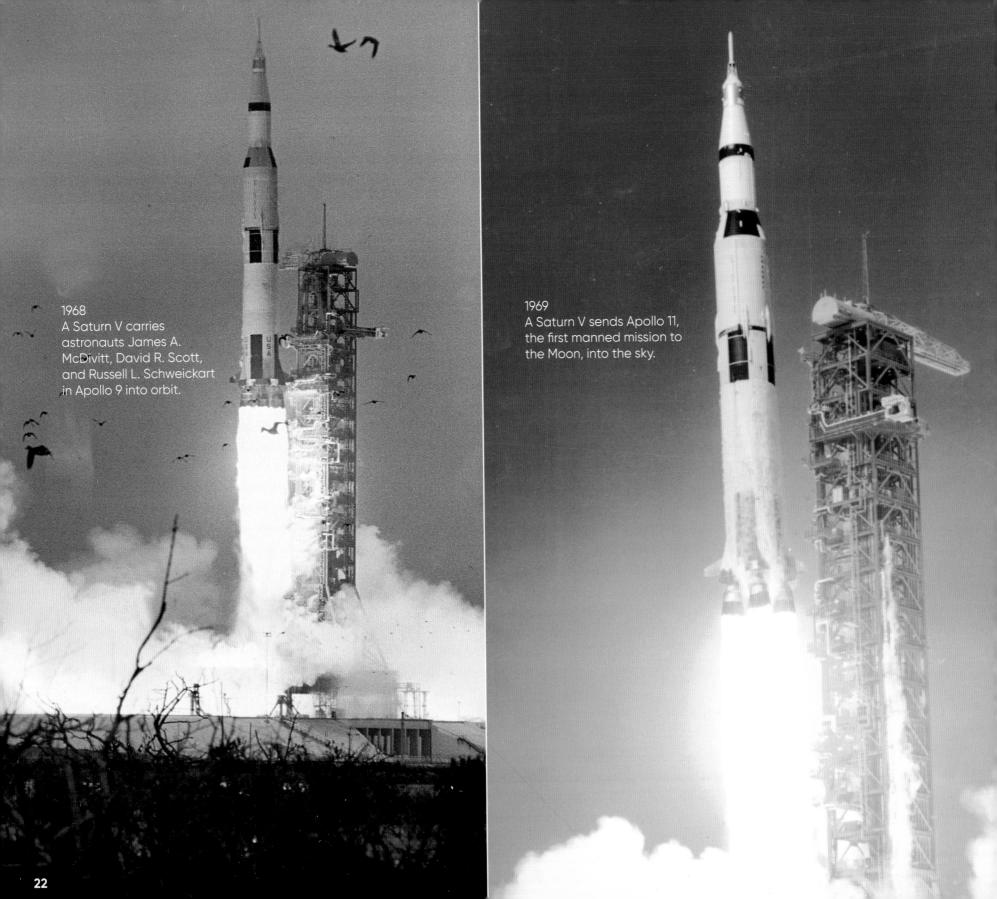

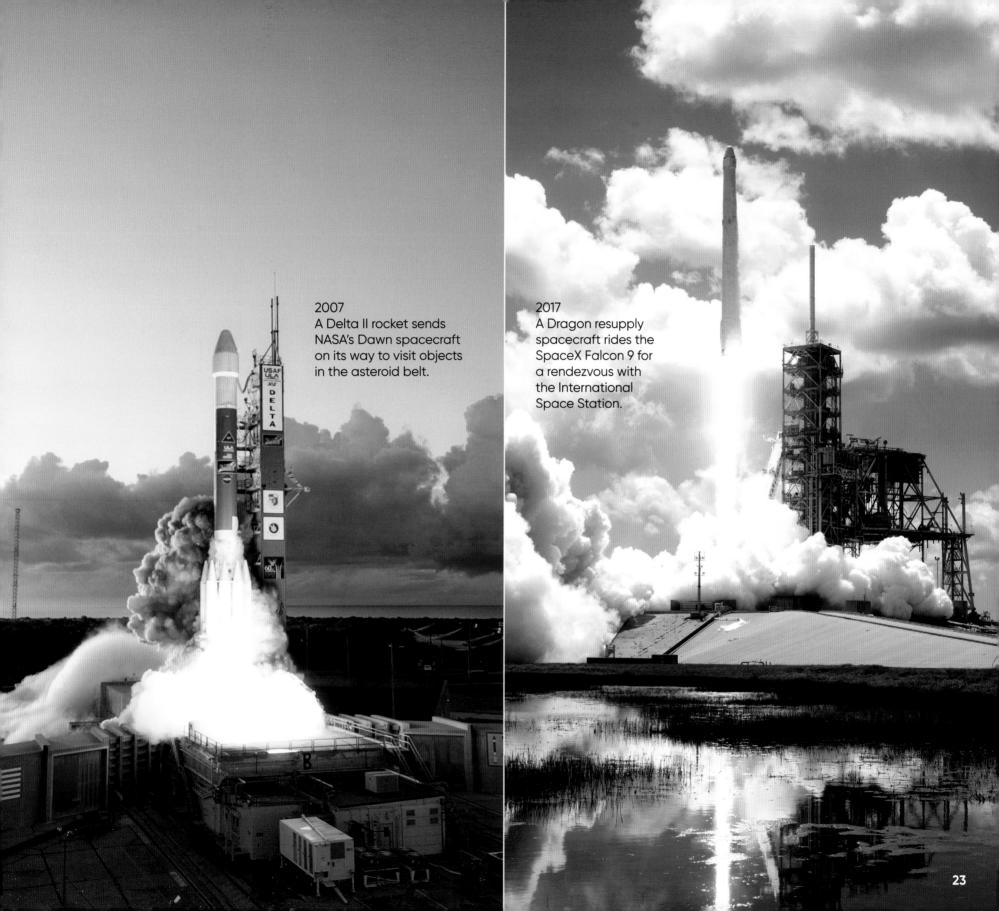

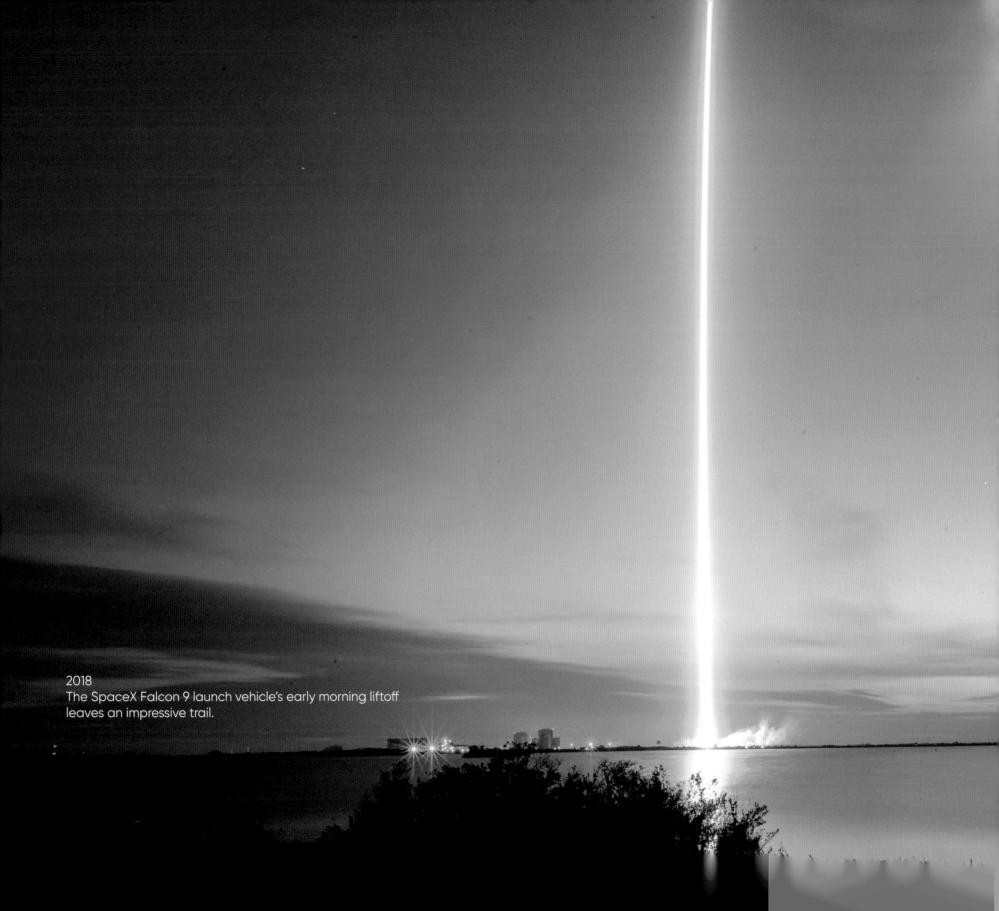

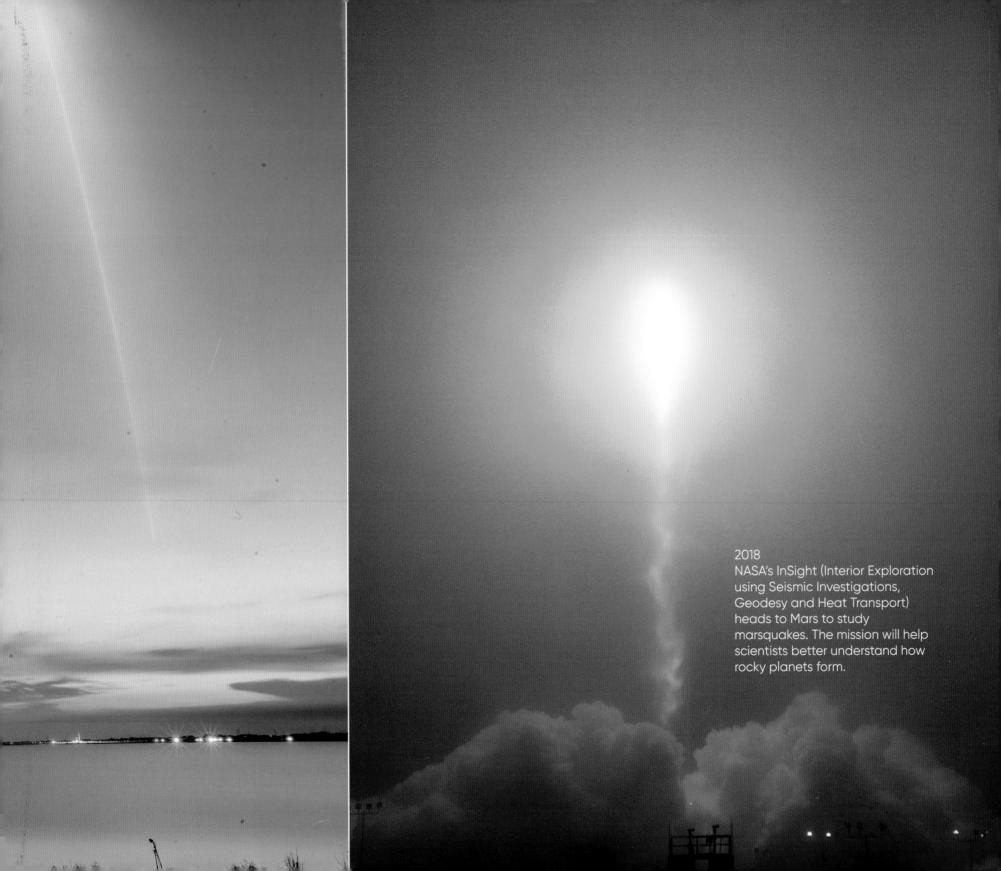

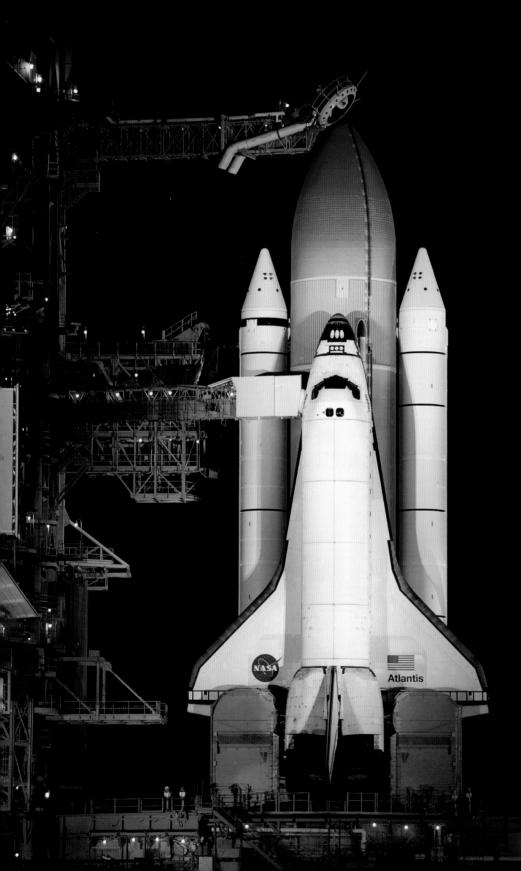

SPACE SHUTTLE

The shuttle program lasted from 1981 to 2011. In that time, its fleet made 21,152 Earth orbits and logged 542,398,878 miles. Each was capable of carrying a payload (food, flight tools, satellites, space suits, and other kinds of equipment) of about 60,000 pounds in its immense cargo bay. Shuttles launched and repaired satellites, provided astronauts with opportunities to conduct experiments, and ferried scientists and supplies to and from the International Space Station.

Shuttles carried about seven people comfortably. Crew would typically board three hours before liftoff. Once in space, shuttles might stay in orbit for a week. The longest a space shuttle ever stayed in orbit was 17.5 days.

NOTABLE NUMBERS

Number of shuttles built: 6 Time to orbit: 8.5 minutes

Largest crew size: 8

Heaviest payload: 25 tons

Total number of crew members: 852

Total time in space: 1,334 days **Length of cargo bay:** 60 feet

Dockings with the International Space Station: $\ensuremath{\mathtt{37}}$

Number of missions: 135

Landing speed at touchdown: 220 miles per hour

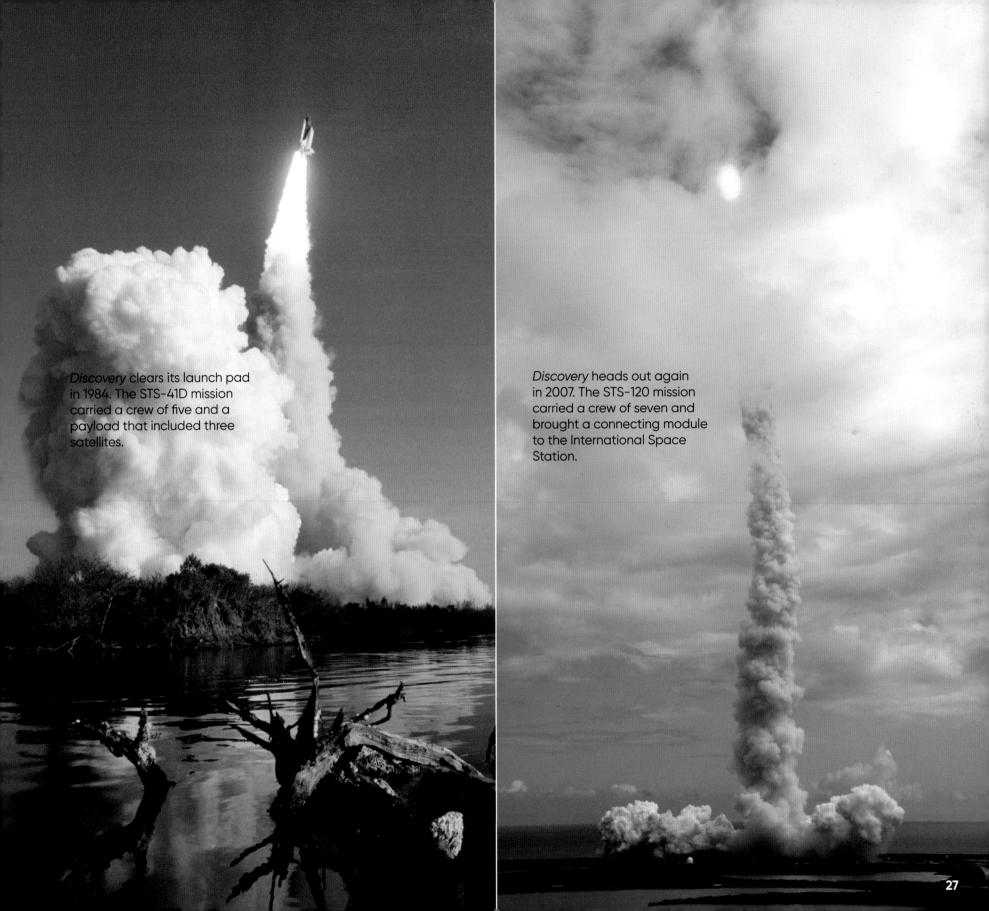

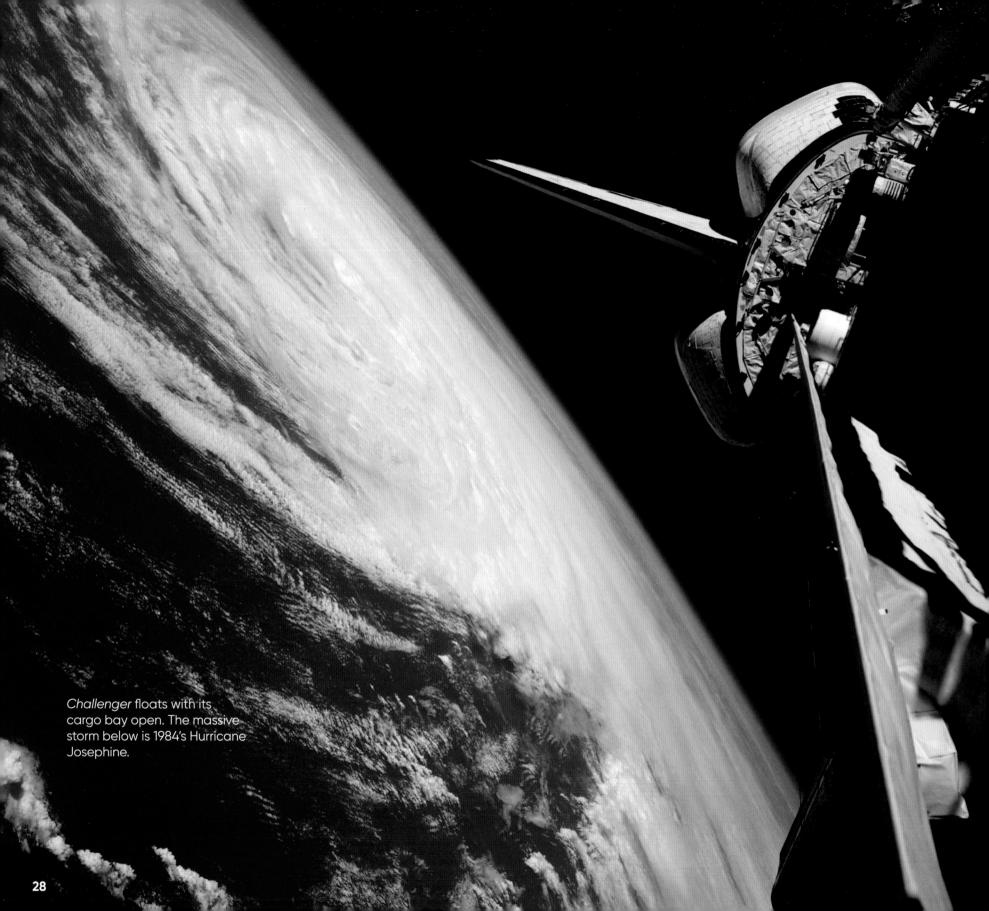

Discovery hangs above the Earth in 1985. The mission's payload included three communications satellites. VSC 1 29 Endeavor touches down at Edwards Air Force Base after a mission to the International Space Station in 2002.

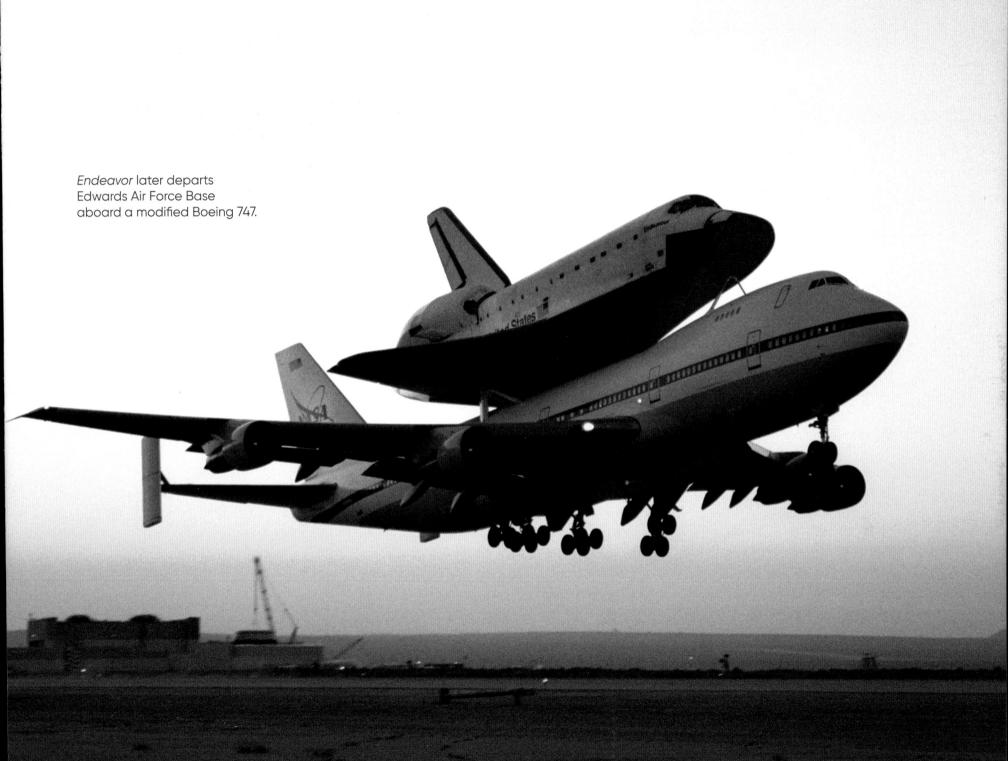

STEP INTO THE VOID

On June 3, 1965, astronaut Ed White left his Gemini 4 capsule and became the first American to perform EVA (extravehicular activity).

In 1969, the crew of Apollo 9 tested out the docking procedures of the Command and Lunar Modules in preparation for the lunar landing mission. Here, astronaut Dave Scott emerges from the hatch of the Command Module.

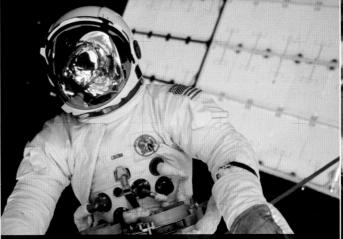

Skylab 3 pilot Jack R. Lousma pauses during equipment installation in 1973. The Earth's reflection was captured in his helmet visor.

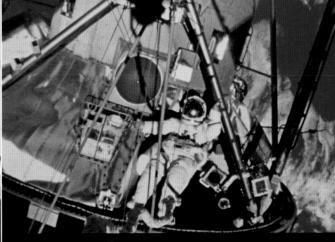

Astronaut Edward G. Gibson on his final Skylab spacewalk in 1974.

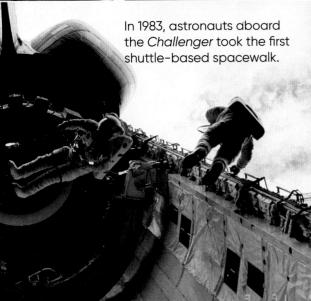

The first untethered spacewalk took place in 1984. Astronaut Bruce McCandless II left *Challenger* and took the Manned Maneuvering Unit for a brief test drive.

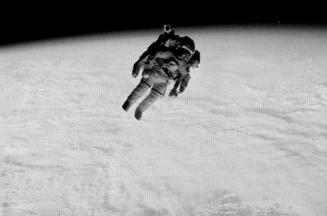

In 1984, astronaut Dale A. Gardner used the Manned Maneuvering Unit to dock with a satellite and stabilize it for capture. It was returned to Earth in the cargo bay of the space shuttle *Discovery*.

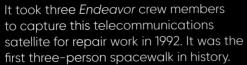

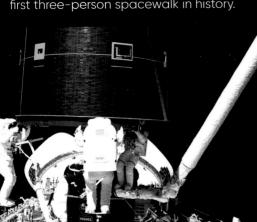

Astronaut Mark Lee tried out the Simplified Aid for EVA Rescue (SAFER) system as he freely floated away from *Discovery* in 1994.

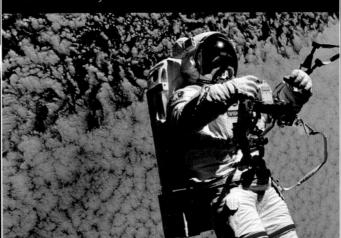

In 2009, astronaut John Grunsfeld visited the Hubble Space Telescope on a final servicing run. He visited the observatory three times on this mission, installing new equipment and making repairs.

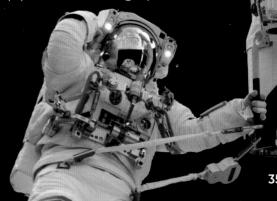

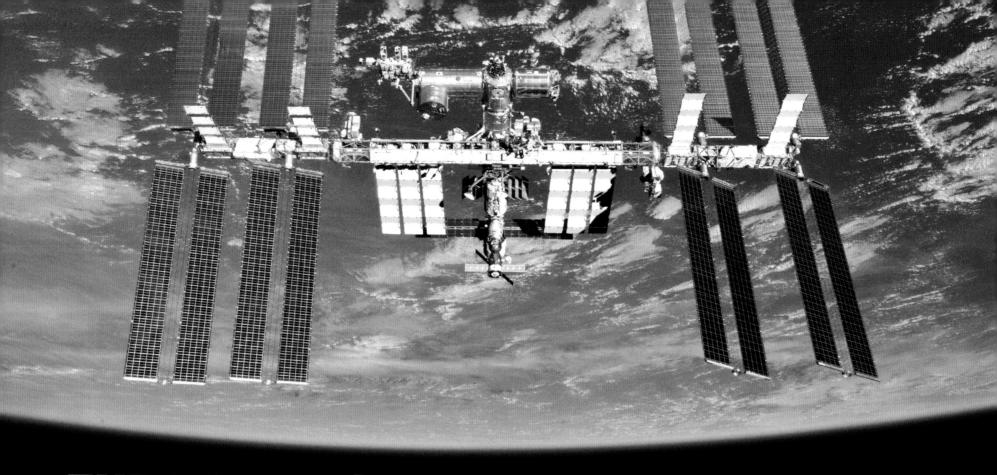

THE INTERNATIONAL SPACE STATION

It isn't humanity's first space station but it's definitely the biggest and best. The ISS is a vast outpost in space that stretches the length of a football field. It weighs nearly a million pounds and is as roomy as a six-bedroom house on the inside. It is run as a cooperative program between the United States, Russia, Canada, Japan, and participating European countries in the European Space Agency (ESA).

Assembly began in 1998. Modular components were sent into orbit piece by piece. The first module, *Zarya*, was launched by a Proton rocket. An American shuttle mission brought *Unity* two weeks later. In 2000, *Zvezda* was added. This module contained life support systems, allowing the first crew of two astronauts to establish residence. More modules, the truss system, and solar

The ISS has been continuously occupied since 2000. It became fully operational in 2009, when it began hosting a rotating crew of six. By the end of 2018, the facility had been visited by well over 200 astronauts and scientists. Crew are typically kept busy with science experiments, maintenance and repairs, and workout regimens (to maintain muscle tone) for over 12 hours a day.

While the research done at the ISS furthers our understanding of life in space, it also has the benefit of improving life on Earth. Experiments with plant growth in space have helped scientists anticipate how to feed astronauts during long-term missions beyond Earth's orbit. These experiments have also helped us learn how to grow stronger plants back on the ground. The ISS has facilitated research in many other areas, including

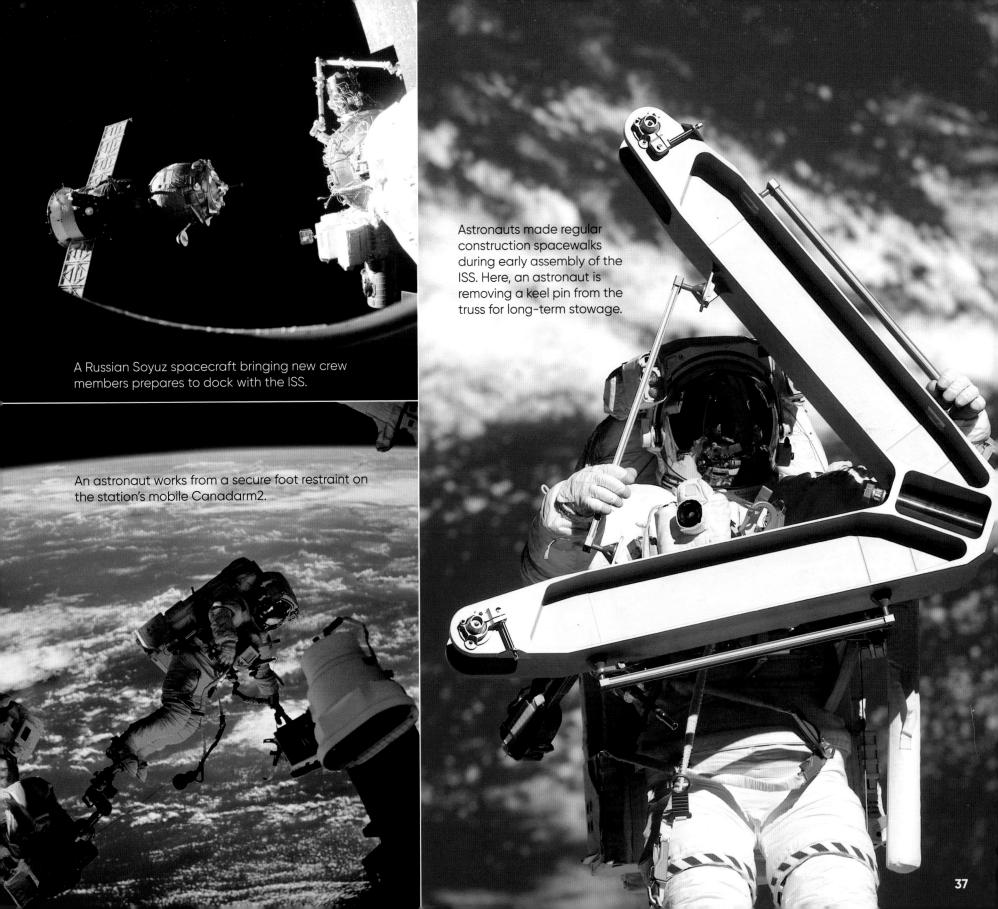

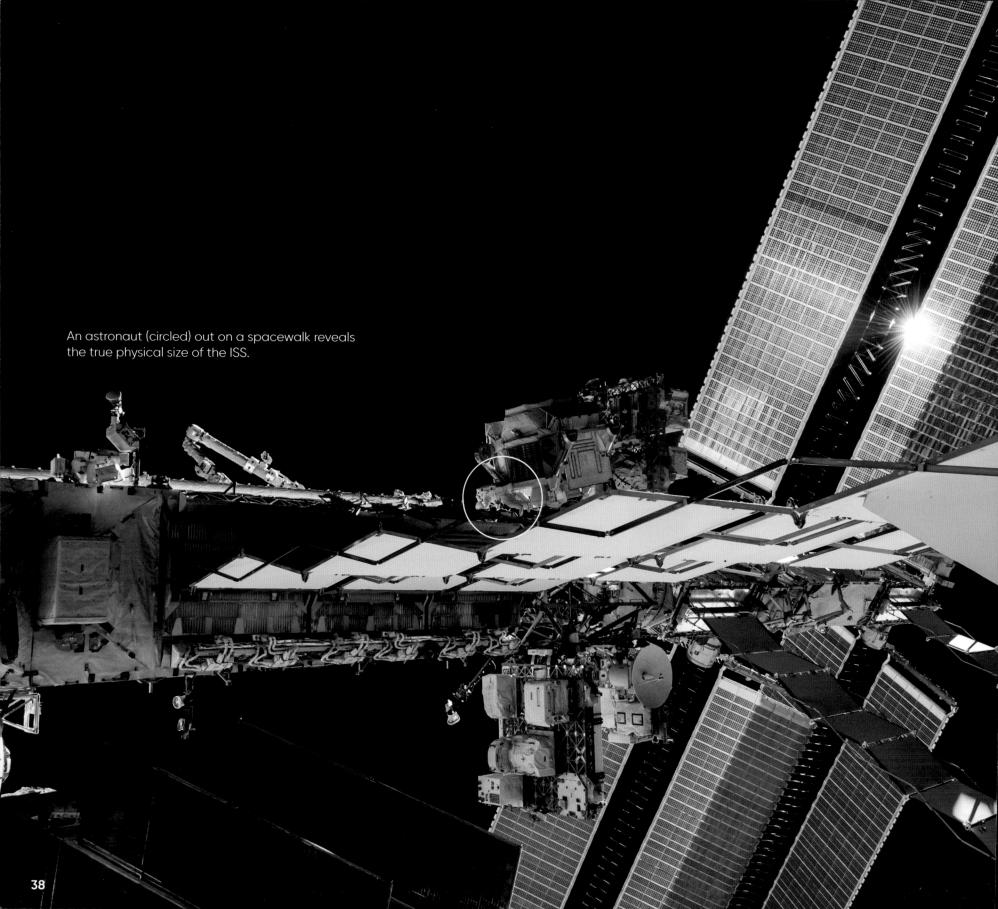

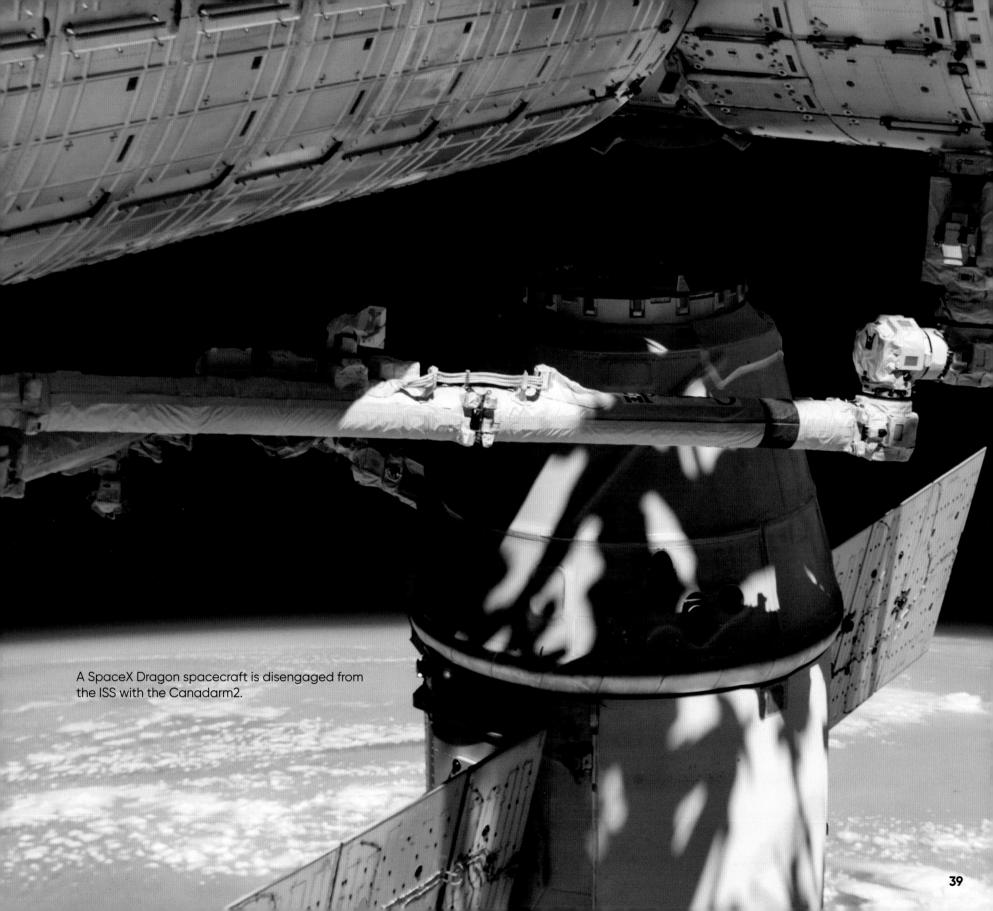

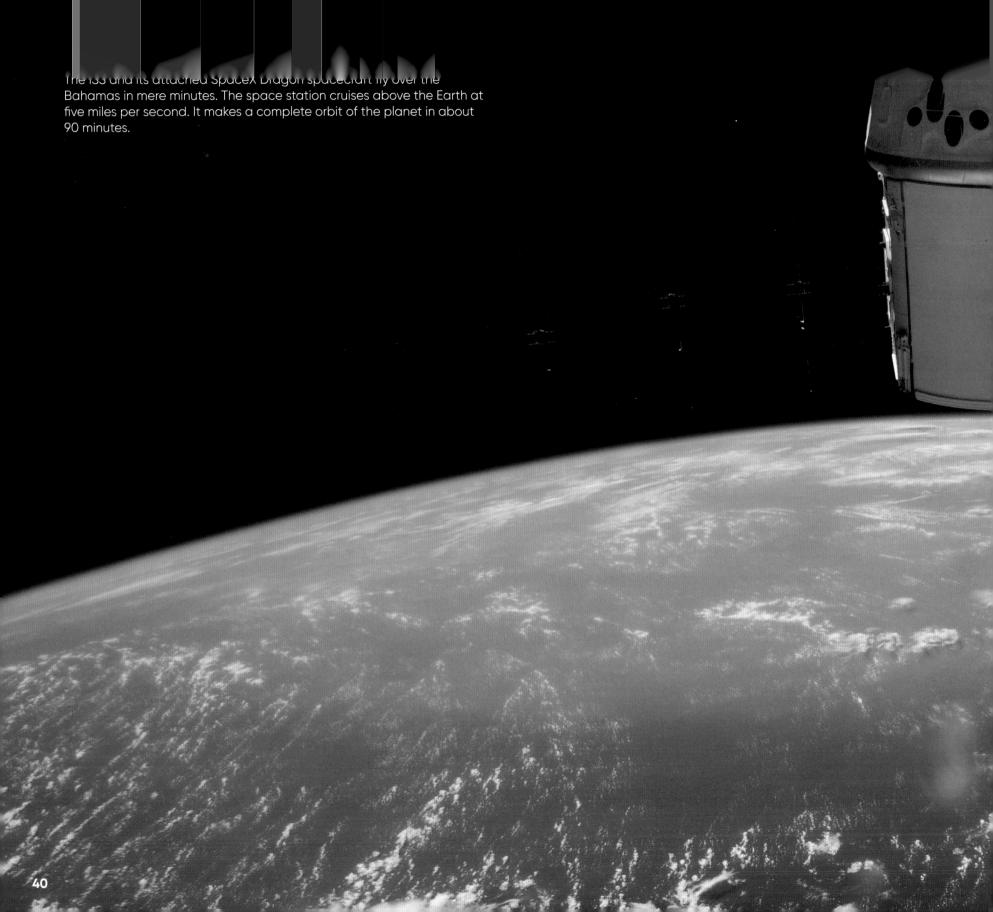

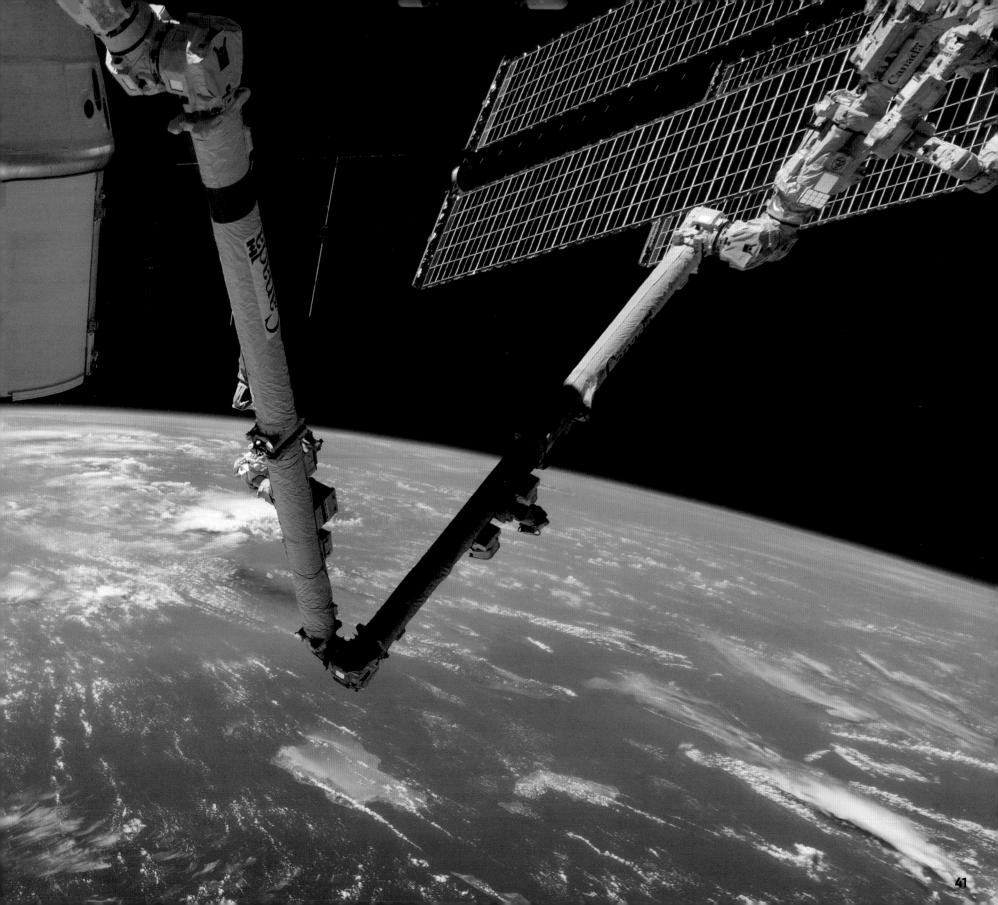

Jur closest celestial neighbor, the
Moon lies less than half a million
miles away. At about one quarter
Earth's size, it has a significant
effect on our planet. The two bodies
gravitationally interact with one
another. Earth's tides are a result
of the Moon's orbit. Over time, this
interaction has caused the Moon to
become tidally locked—the same
side always faces the Earth.

Darker areas, known as *maria* (Latin for "seas"), are the result of ancient lava flows.

Lighter areas indicate highlands, the oldest parts of the Moon's surface.

Impact craters cover the surface of the Moon. Some, like the Tycho crater, are clearly visible from Earth.

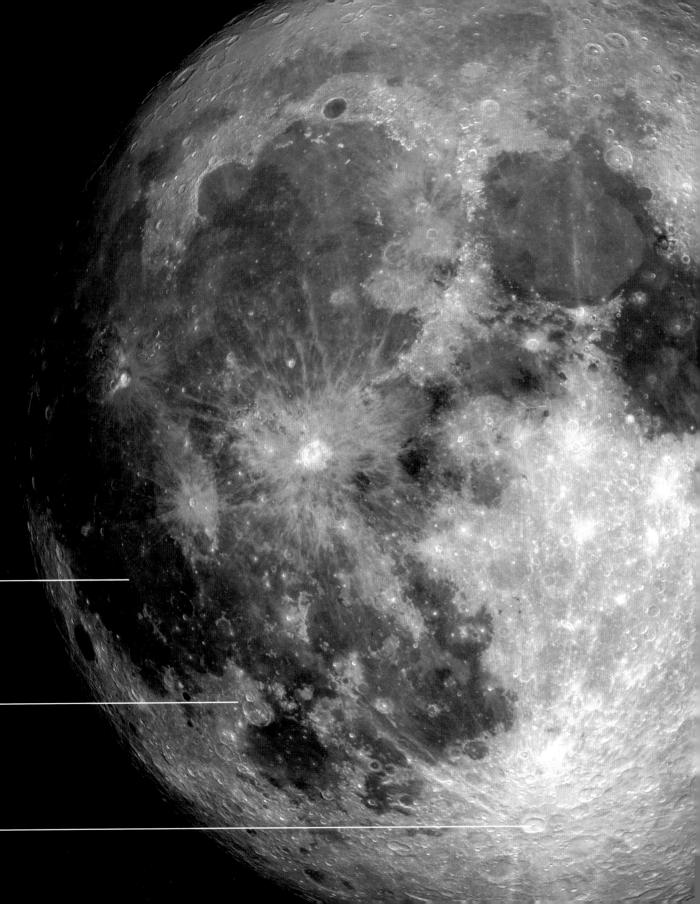

A view of the Moon above the Earth's horizon. This photo was taken by ISS crew in 2018.

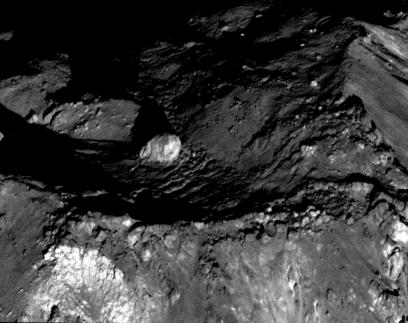

NASA's Lunar Reconnaissance Orbiter Camera (LROC) took this close-up image of the Tycho crater's central peak in 2017. The spacecraft was launched in 2009. LROC's mission has been to extensively map the surface of the Moon, identifying safe landing sites and resources in the process.

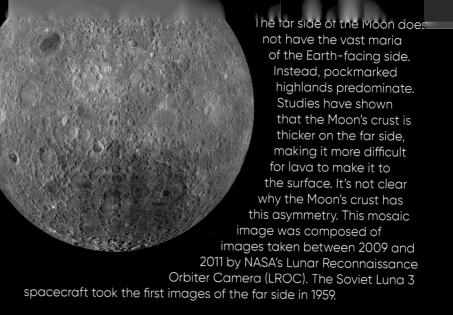

The Apollo 8 spacecraft took these photos in 1968 as it circled the Moon. It became the first mission to take humans to the Moon and back.

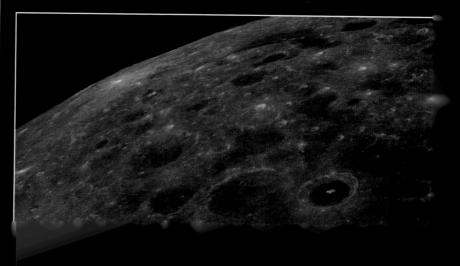

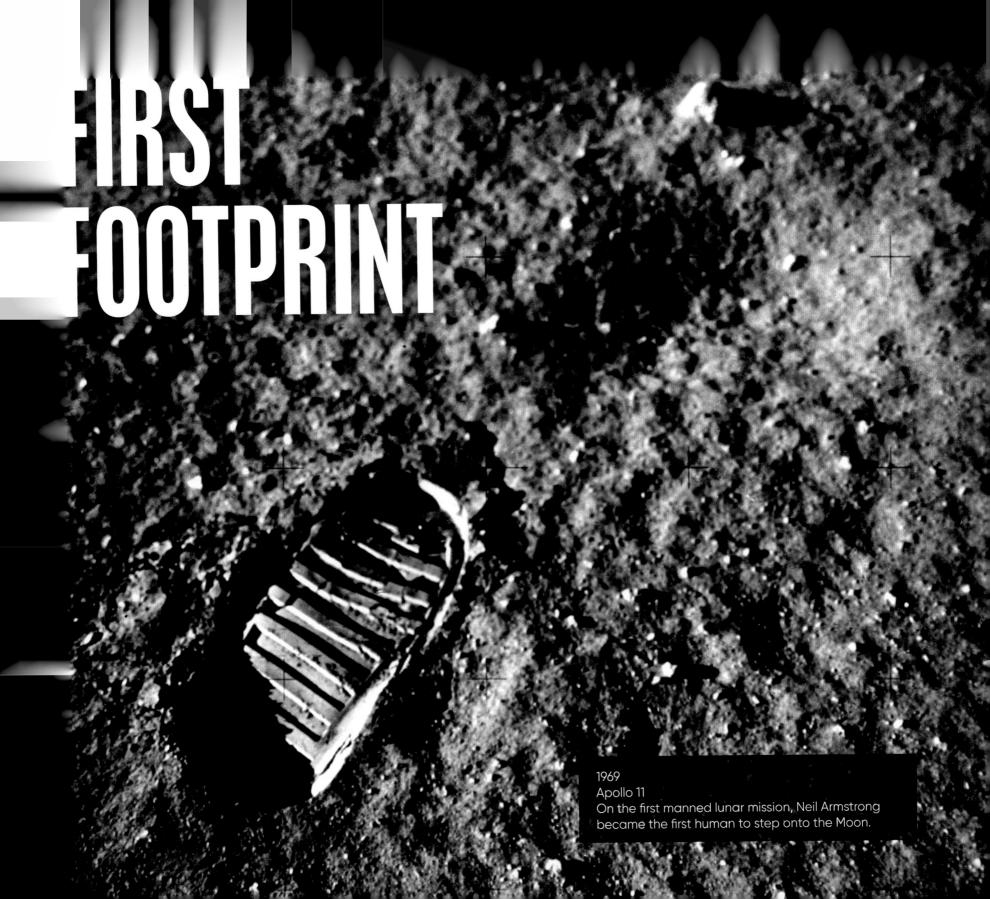

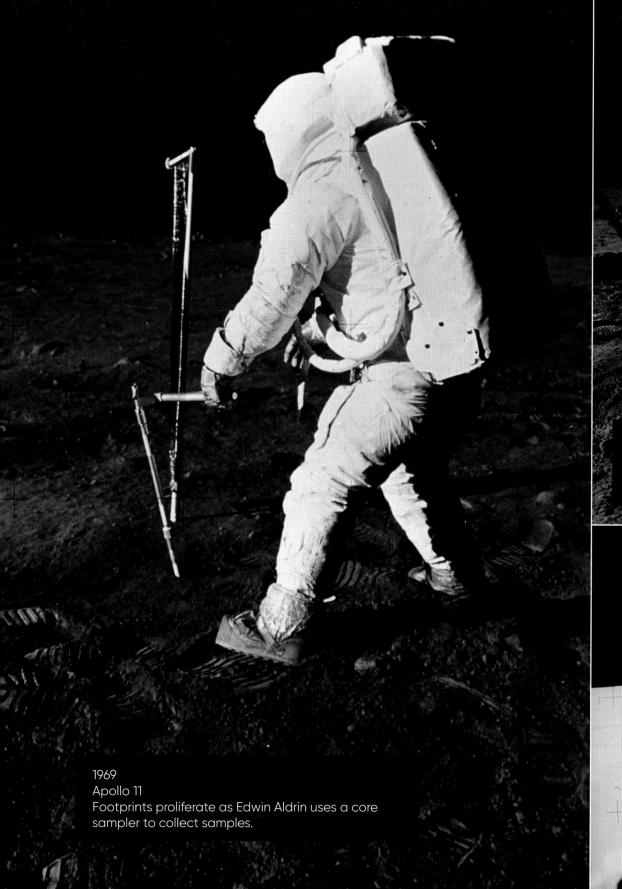

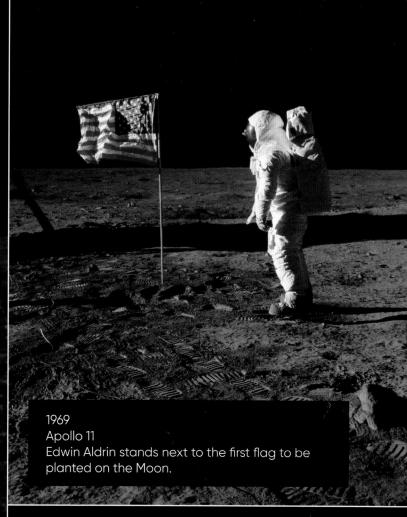

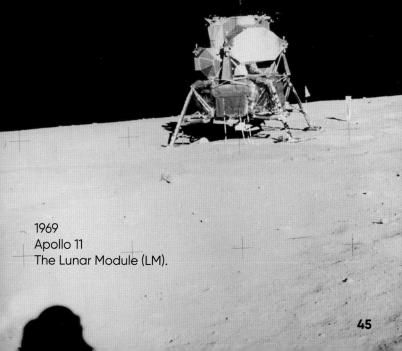

1969 Apollo 12 Alan L. Bean walks during the mission's first extravehicular activity. A lunar surface TV camera stands to the right.

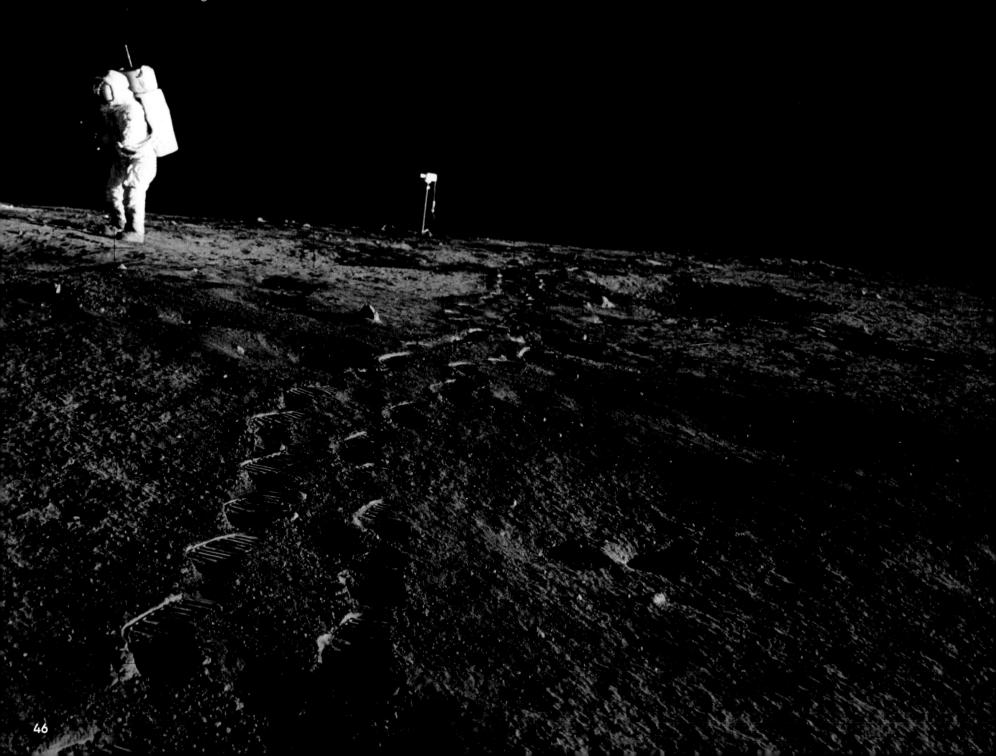

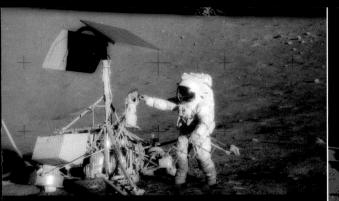

1969
Apollo 12
Charles Conrad Jr. next to Surveyor 3, an unmanned spacecraft that landed on the Moon in 1967. The Lunar Module (LM) stands in the background.

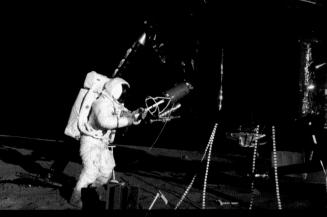

1969
Apollo 12
Alan L. Bean retrieves the fuel element that will be used to power a generator on the Apollo Lunar Surface Experiments Package (ALSEP).

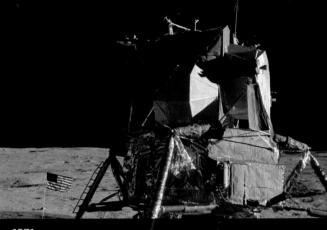

1971 Apollo 14 The Lunar Module is photographed at the beginning of the mission's first EVA.

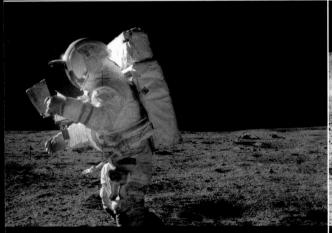

1971 Apollo 14 Edgar D. Mitchell checks his map before exploring the lunar surface.

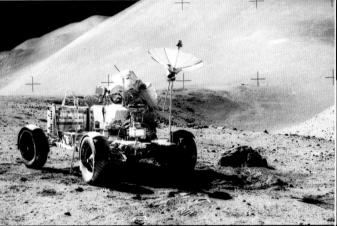

1971
Apollo 15
The Lunar Roving Vehicle (LRV) allowed astronauts to travel miles from their landing sites.

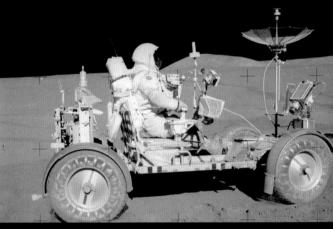

1971 Apollo 15 David R. Scott seated in the Lunar Roving Vehicle (LRV).

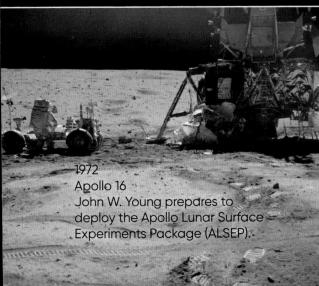

1972 Apollo 17 Harrison H. Schmitt next to a massive split boulder.

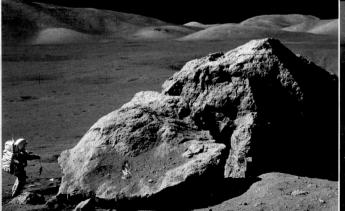

1972
Apollo 17
A wide-angle view of EVA in progress at the Taurus-Littrow landing site.

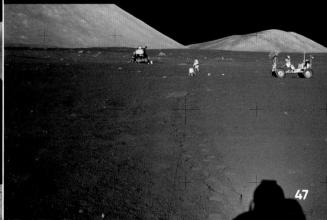

MERGURY

Smallest of the eight planets, closest to the Sun, tiny Mercury is a barren world practically devoid of atmosphere and blasted by intense solar radiation. Mercury is nearly tidally locked to the Sun; a single day on Mercury is equivalent to about 59 Earth days. Temperatures on the day side can hover near 800 degrees Fahrenheit and plunge to nearly 300, below during the long night. Like the Moon, Mercury's surface is packmarked with craters. Basins, deep trenches, soaring cliffs, and crater rays crisscross the battered surface. Some of the deep unlit craters near the poles contain water ice.

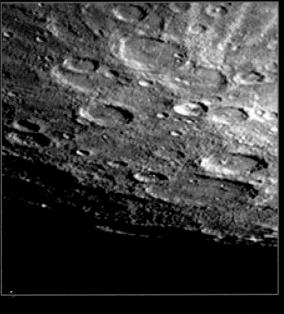

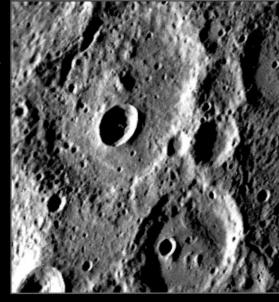

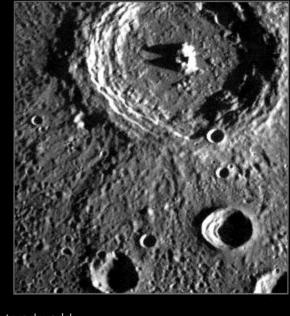

Mariner 10 was the first probe sent to study Mercury's surface. It sent back images of a densely cratered world.

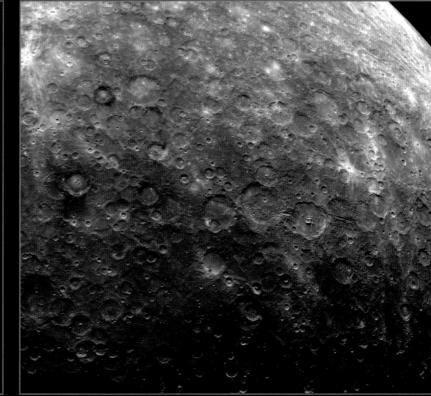

VENUS

Venus is the second-closest planet to the Earth and easily seen by the naked eye. The beautiful point of light we call both "morning star" and "evening star" may seem like a jewel in the twilight sky, but Venus is actually a hellishly hot place. Venus's atmospheric pressure at the surface is so intense that it would feel like being over a mile beneath the ocean to us. Because of the combination of heat and pressure, the few Russian spacecraft that landed on its surface were quickly melted and crushed. The toxic atmosphere is hot enough to melt lead.

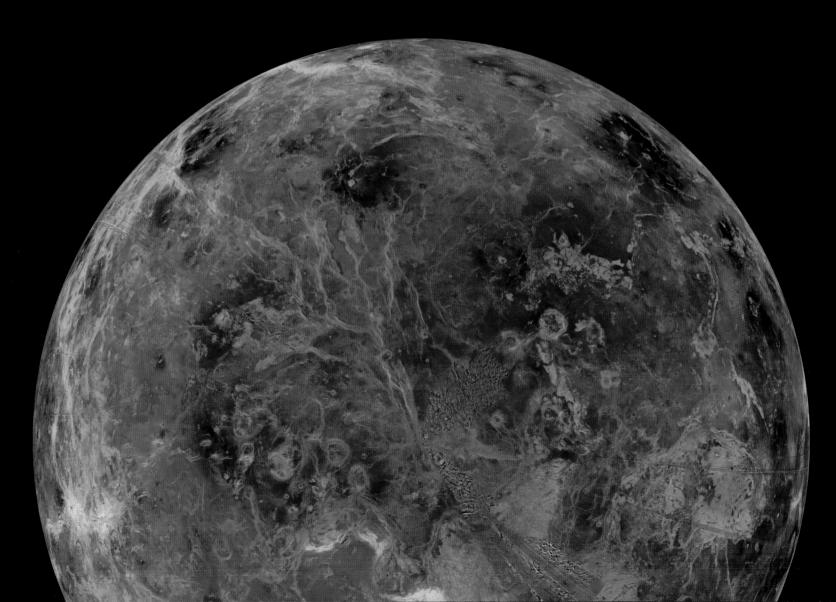

We know a little about Venus' topography thanks to radar mapping that has been done at a safe distance. The Magellan mission (1989–1994) gave us some of the most detailed information about the surface of this seething world. NASA's Solar Dynamics Observatory (SDO) captured this image of Venus making a transit across the face of the Sun in 2012. Venus is about 0.7 times Earth's distance from the Sun.

MARS

No other planet in our solar system has caused as much speculation as the faint red dot that wanders our night sky. As a nearby neighbor of the Earth, it is regularly visible from the ground, and uniquely red in appearance. It's only about half the size of our planet, but its surface boasts some of the most spectacular scenery in the solar system. The Valles Marineris canyon is four times longer and six times deeper than the Grand Canyon in Arizona. The shield volcano Olympus Mons is about the size of New Mexico. Vast regions of the planet can be covered in immense dust storms that obscure the surface from observation for weeks at a time.

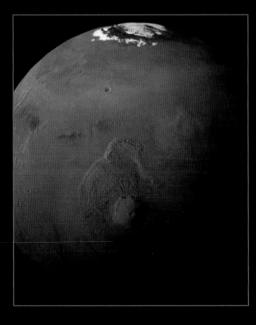

The immense feature rising from the lower center of the planet is Olympus Mons, the largest mountain in the solar system. This extinct volcano is more than three times higher than Mount Everest.

Valles Marineris is the largest canyon in the solar system. It is about 500 miles long—long enough to stretch from Los Angeles to New York City—and over a mile deep.

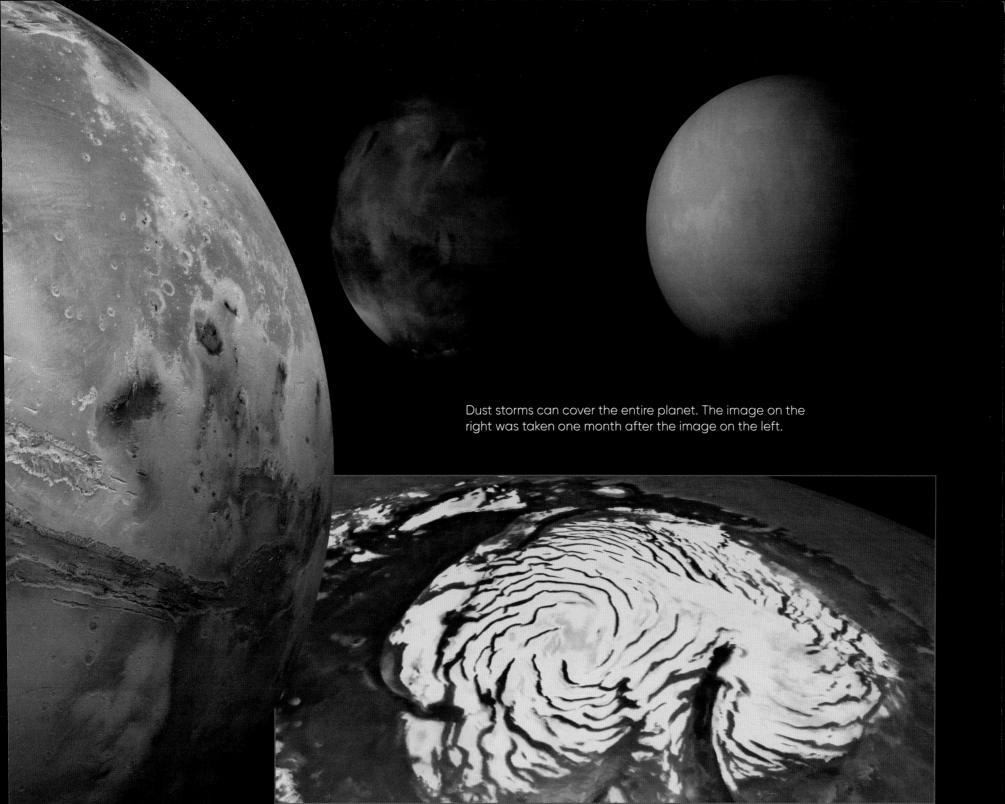

FROM THE GROUND

Multiple missions have attempted to reach the surface of the Red Planet. Many have failed. The very first successful landing occurred in 1971, when a Russian lander touched down and managed to transmit 20 seconds of data before malfunctioning. The first successful American lander, Viking 1, touched down in 1976. In the six years this mission lasted, it studied the surface and took soil samples. Numerous Russian and American missions ensued, followed by attempts by Japan, the ESA, India, and China.

Decades after the Viking landers of the 1970s, more sophisticated exploration vehicles began arriving on the surface. The first roving robotic vehicle—NASA's Sojourner—touched down in 1997. The Spirit and Opportunity rovers followed in 2004. The Curiosity rover arrived in 2012.

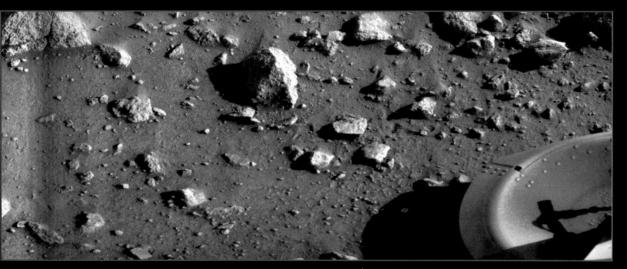

1976 Viking 1 lander First photograph taken on the surface of Mars.

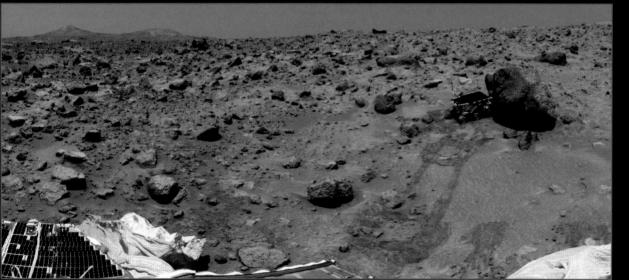

1997
Mars Pathfinder: Sojourner
The tiny Sojourner rover is seen
here near a large rock. Pathfinder's
deployment ramp leading down from
the Pathfinder lander is visible in the
foreground.

2006 Mars Exploration Rover: Spirit Volcanic boulders litter the sand in Spirit's path.

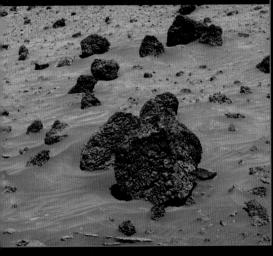

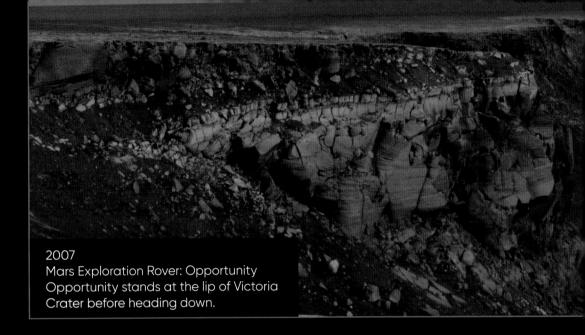

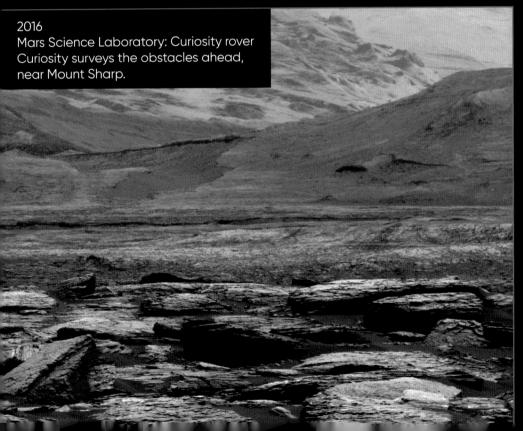

Mars Science Laboratory: Curiosity rover Curiosity gets a close view of the winderoded sandstone formations within the Murray Buttes, on lower Mount Sharp.

A RING OF ROCKS

Some of the most interesting objects in our solar system are the smallest. The asteroid belt is a wide, diffuse circle of small rocky bodies orbiting the Sun between Mars and Jupiter. This band of asteroids may have begun as a number of larger objects that were broken apart in a collision with another planet early in our solar system's history, or it could be material left over from when the solar system was formed. There are also other asteroid groups in the inner solar system.

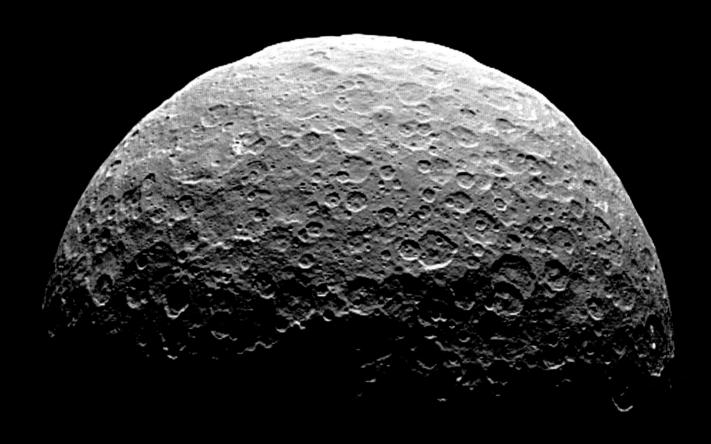

NASA's Dawn spacecraft zoomed in on Ceres in 2015. With a radius of 294 miles, Ceres is the largest object in the asteroid belt. It was reclassified as a dwarf planet in 2006. Unlike most of the other objects in the asteroid belt, Ceres is spherical.

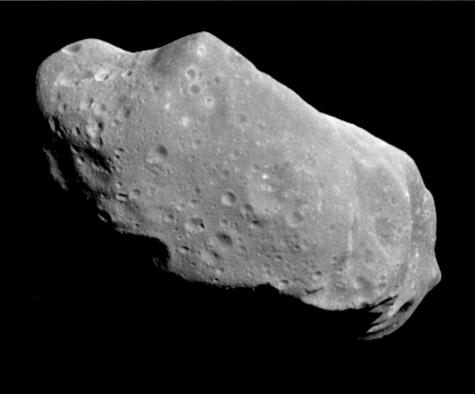

Ida is only 35 miles long, but it has its very own "moon," a tiny satellite named Dactyl.

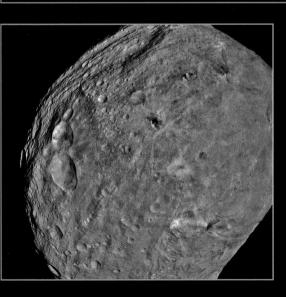

The Dawn spacecraft took this photo of Vesta in 2011. With a radius of 165 miles, Vesta is the second-largest object in the asteroid belt.

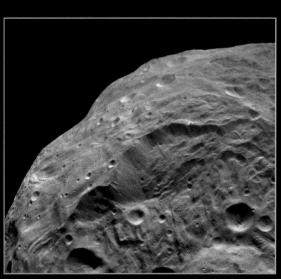

Though a small body with low gravity, Vesta is still large enough to have landslides where impact craters have created steep sides.

NEAR Shoemaker was the first mission to touch down on the surface of an asteroid. It made contact with the Eros asteroid in 2001. This image was taken when Shoemaker was 2,300 feet above the surface.

Jupiter is the largest planet in the solar system and more than twice as massive as the rest of the planets combined. Seen from space, the planet's great swirling bands of orange, cream, and brown seem like serenely vibrant tapestries. But these beautiful bands and ripples are anything but serene. Jupiter is an incredibly turbulent planet, with surface winds constantly blowing at several hundred miles per hour. Violent storms can form within hours and grow to thousands of miles in size in a single day.

Light areas are called zones. They indicate areas where gas is rising.

Dark areas are called belts. In these regions, the atmosphere is sinking.

Zones and belts alternately flow east and west. Turbulent interactions between zones and belts are called zonal jets.

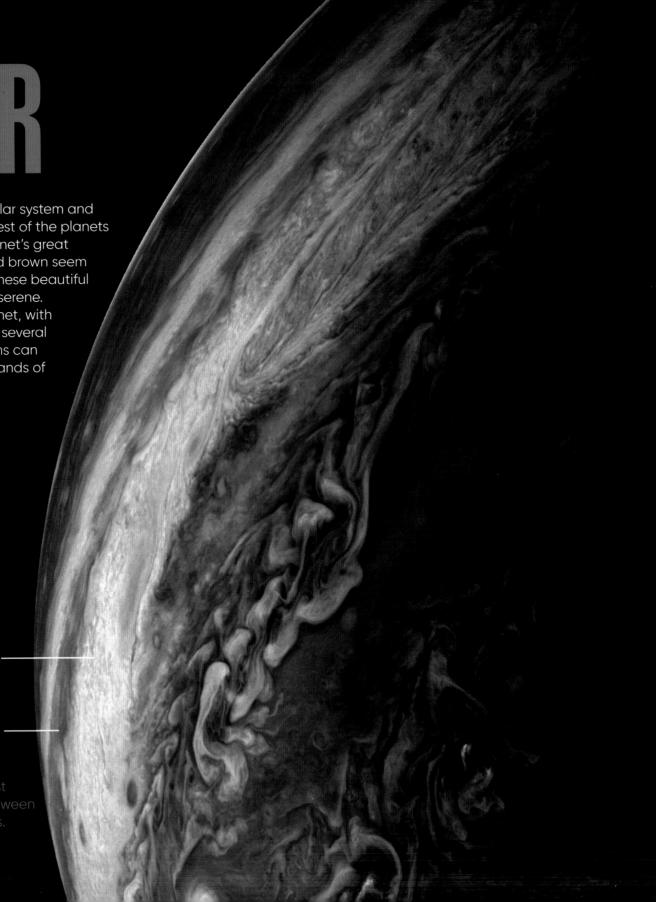

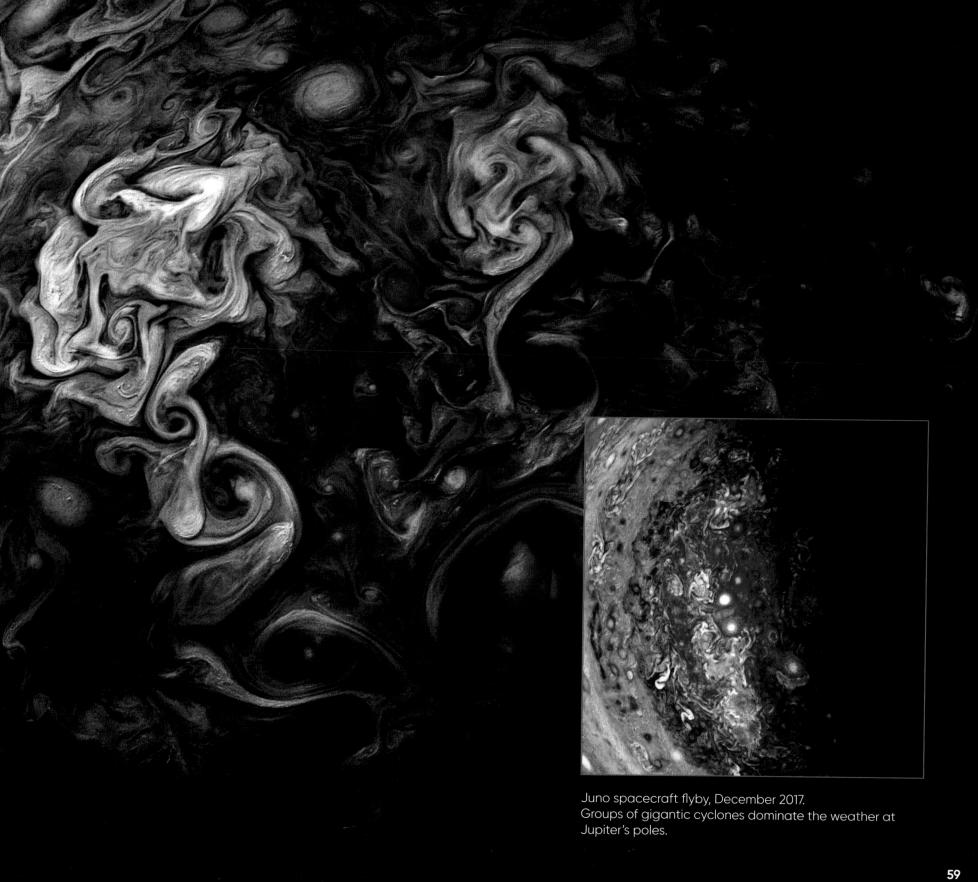

The Juno spacecraft's close views of Jupiter reveal a turbulent atmosphere of powerful jets, vortices, and spinning storms. 60

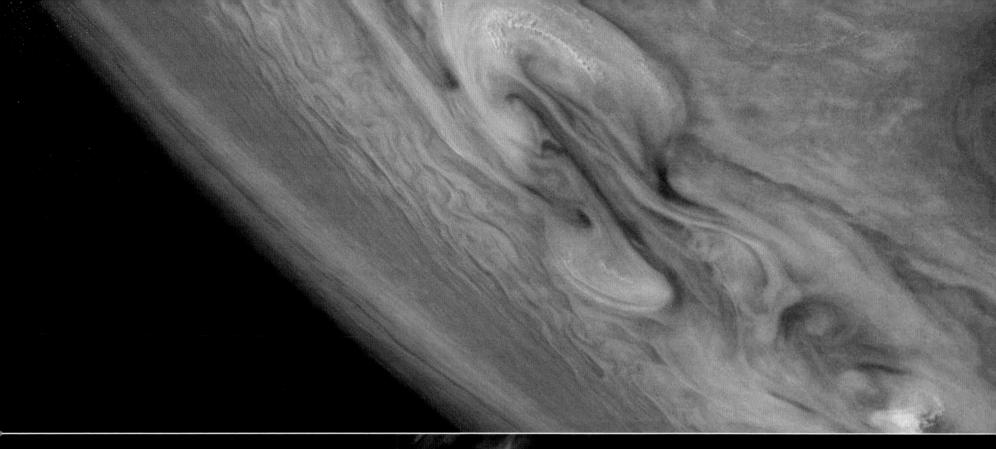

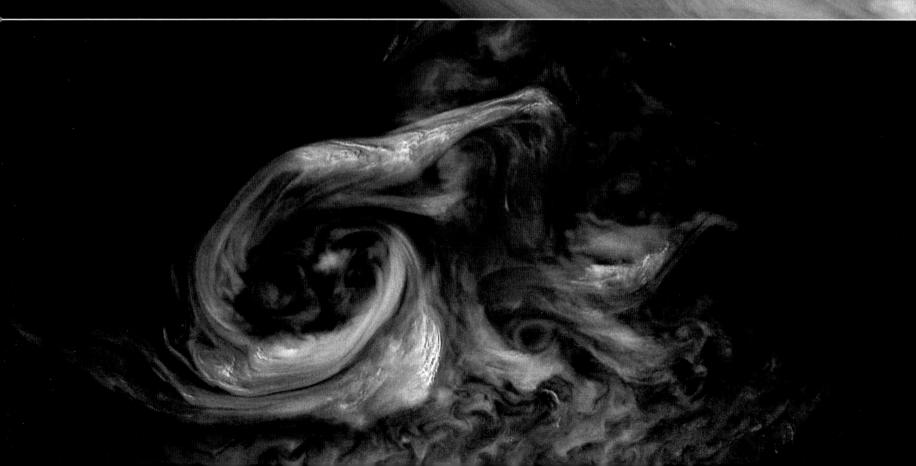

A STORM LARGER THAN EARTH

What is it? What caused it? Jupiter's Great Red Spot has vexed astronomers since it was first definitively observed more than a century ago. Its age is uncertain (it may be several centuries old), and while it has shrunk in recent decades, estimates of its lifespan are still up for debate. It is the largest known storm in the solar

system. In meteorological terms, it is an anticyclonic circulation system over 10,000 miles wide. It makes a full rotation in about six days. Winds within the system can exceed 400 miles per hour. Data from NASA's Juno spacecraft indicate that the storm has roots extending 200 miles down into Jupiter's atmosphere.

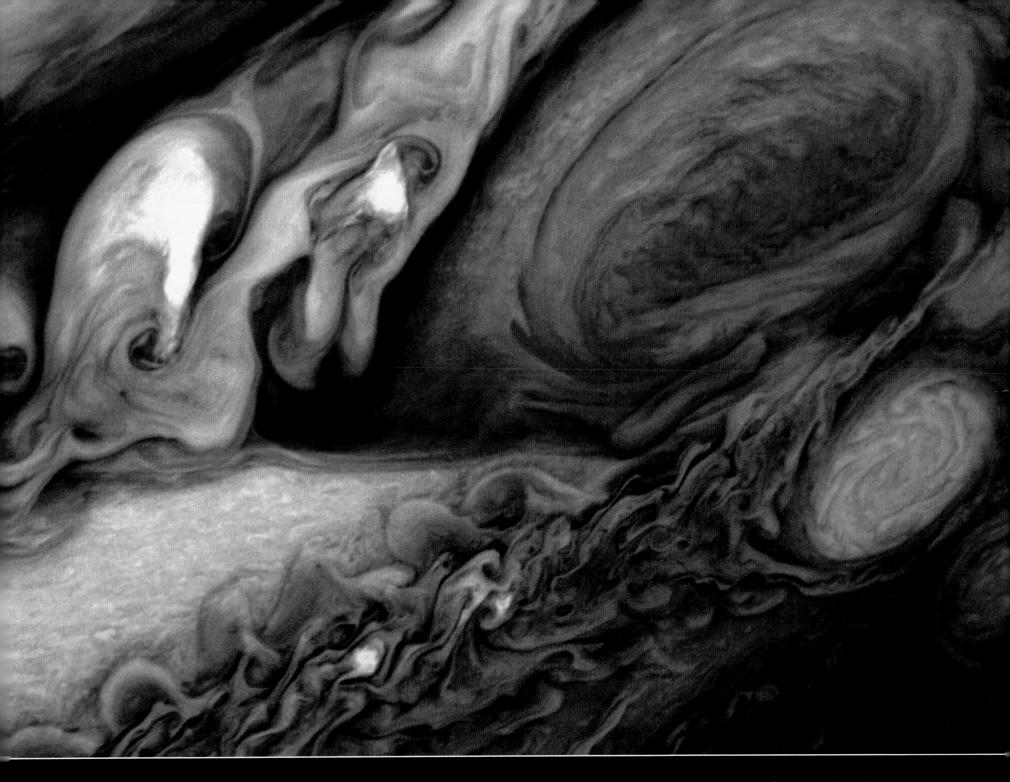

Another unsolved mystery: why is it red in the first place? Scientists have theorized that the concentrated presence of sulfur and phosphorus in the chemical makeup of the storm contributes to the color. Others speculate that churned up chemicals being broken down by sunlight may be the explanation. It's possible that the sheer altitude of the storm may expose it to ultraviolet light from the sun, leading to a photochemical reaction

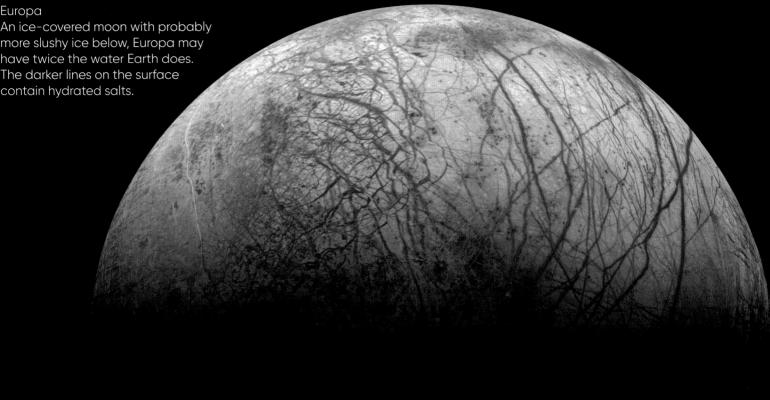

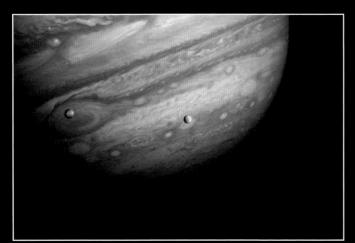

The two moons crossing Jupiter's face are Io (left) and Europa (right).

Craters like this one are rare on Europa. The moon has a young surface that may be no more than 90 million years old.

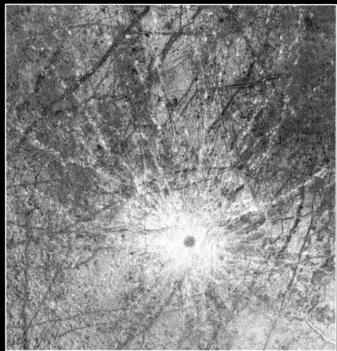

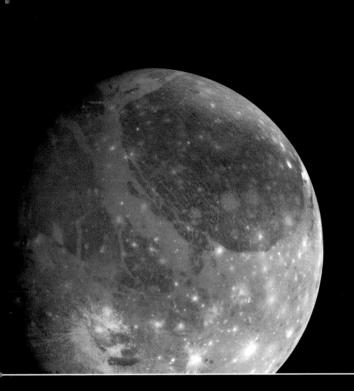

Ganymede
The largest moon in the solar system is also the only one to have its own magnetic field. Ganymede's pocked surface is composed mostly of ice.
The darker areas are older and more heavily cratered.

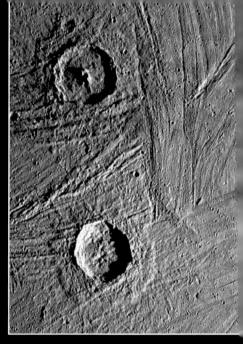

A grooved terrain is the result of tensional faulting.

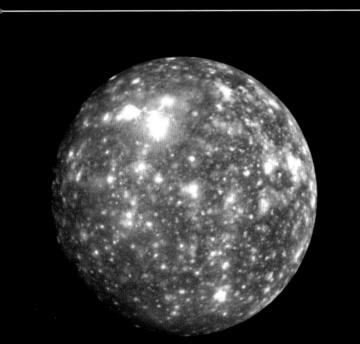

Callisto
Callisto's ancient, cratered face
reveals a record of bombardment
that goes back to the early history of
the solar system. In fact, it may have
the oldest landscape in our solar
system.

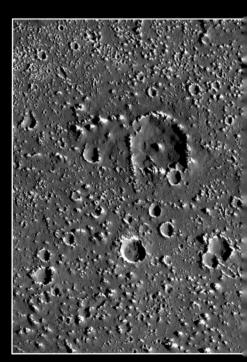

The most heavily cratered surface in the solar system

SATURN

The gas giant Saturn is the second-largest planet in the solar system and similar in some ways to Jupiter. Its outer atmosphere is banded, it has a vast system of moons (62 as of 2018, with 53 given official names), it rotates rapidly, and its composition is

mainly hydrogen and helium. It is the least dense of the planets. Saturn does experience violent storms like Jupiter, but they are visually muted seen from space. These storms may appear as pale white ovals.

Huygens probe (landing on Titan): 2004

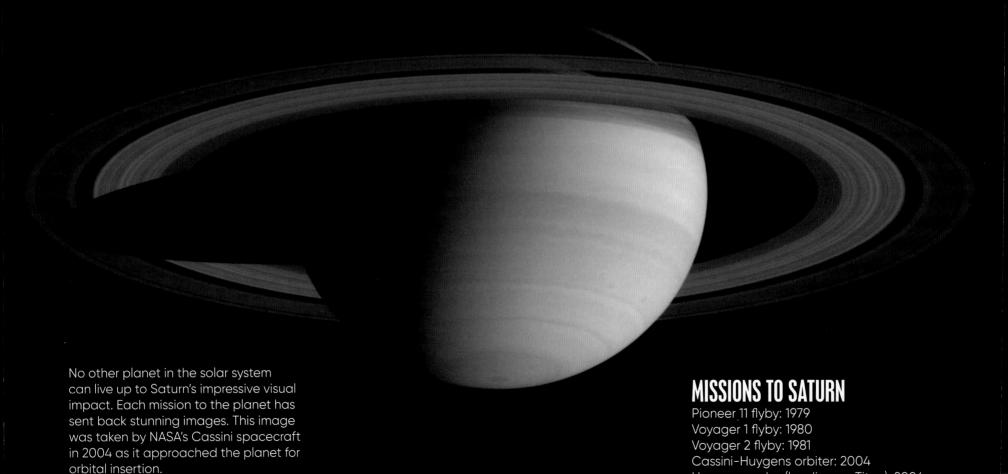

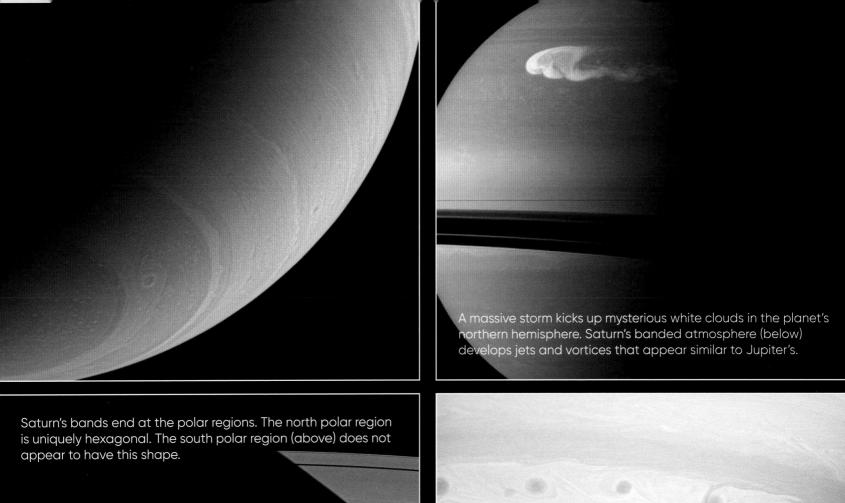

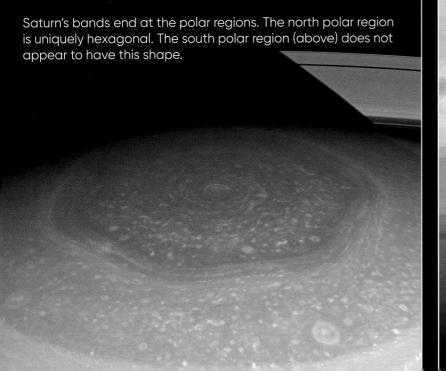

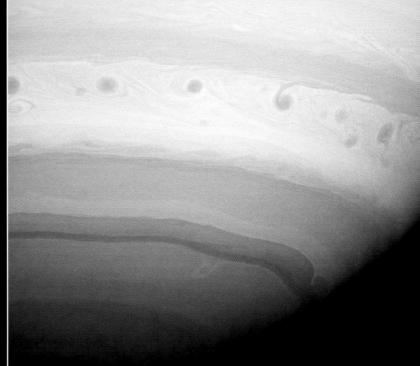

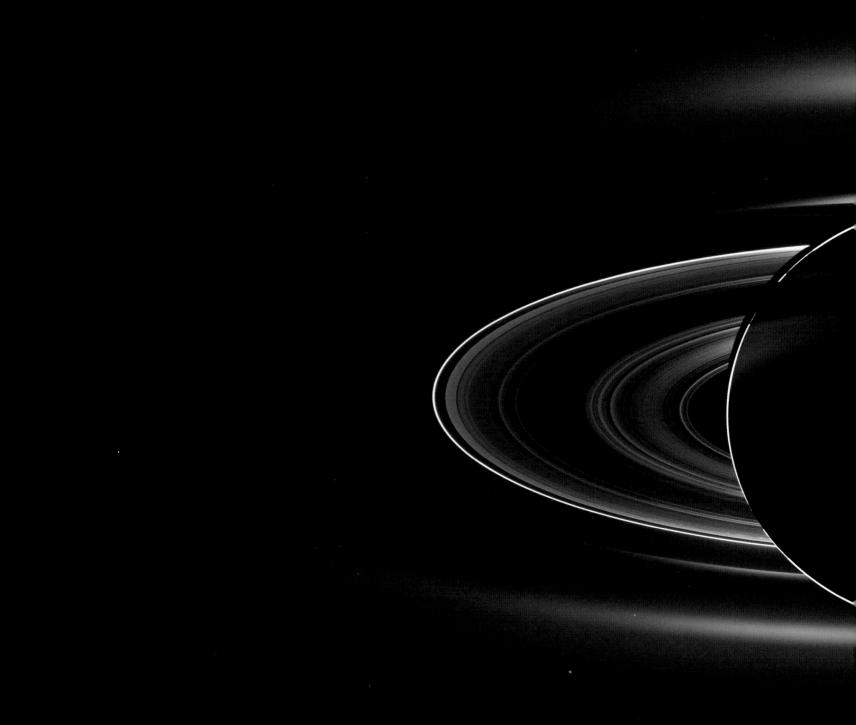

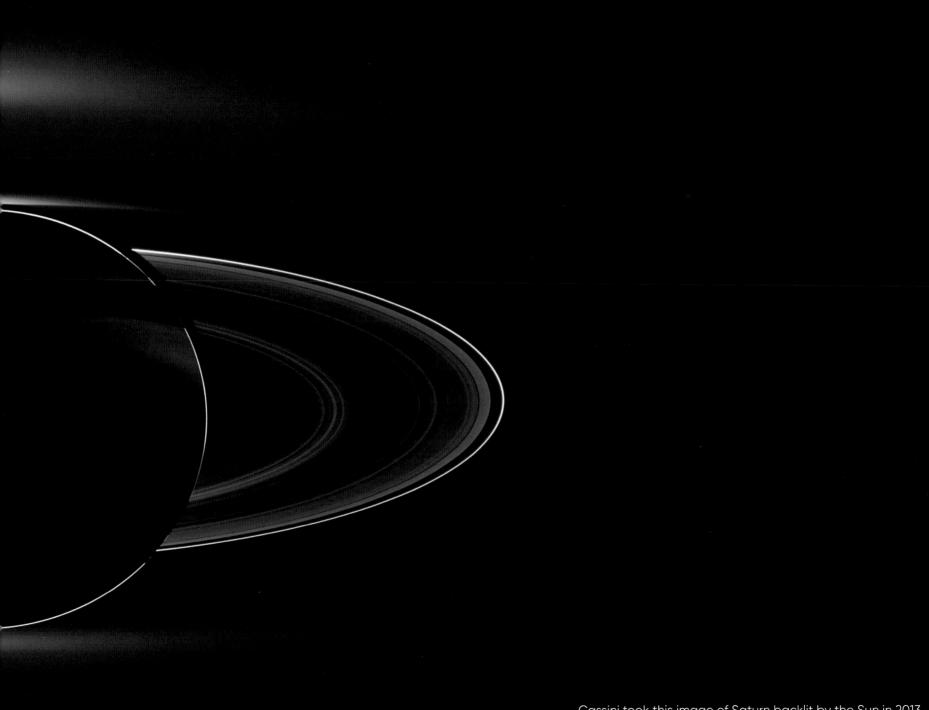

Cassini took this image of Saturn backlit by the Sun in 2013. The unique perspective allowed scientists to see new details in the rings.

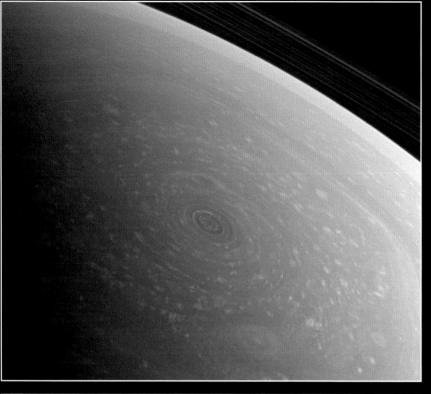

Sunlight illuminates Saturn's north pole. The close view below reveals the planet's high-speed polar vortex.

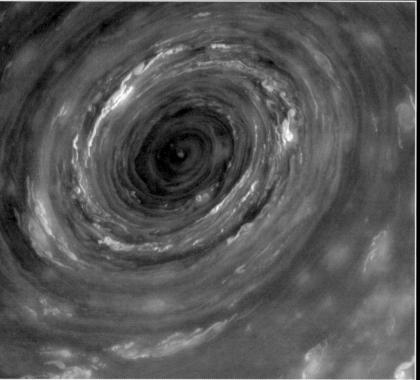

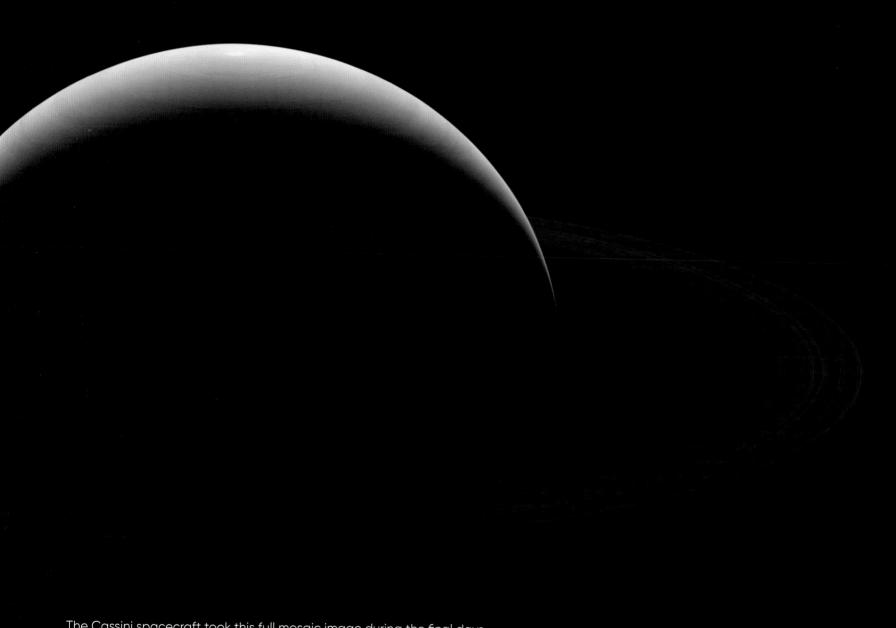

The Cassini spacecraft took this full mosaic image during the final days of its operation. The probe was programmed to plunge into Saturn's atmosphere at the end of its mission.

LORD OF THE RINGS

When Galileo turned his new telescope toward Saturn in 1610, he was surprised to discover that it did not appear perfectly spherical. Western astronomers had always assumed that all heavenly bodies were symmetrical in shape. But there was something very strange about this object, when magnified. It seemed to be three objects lumped together. Over time,

the two end objects faded. Then they came back. Galileo had discovered Saturn's rings. Because the rings are slim and because Saturn is tilted on its axis like Earth, one or more times every 15 years the rings actually disappear from our view for a short time. This event is known as ring plane crossing.

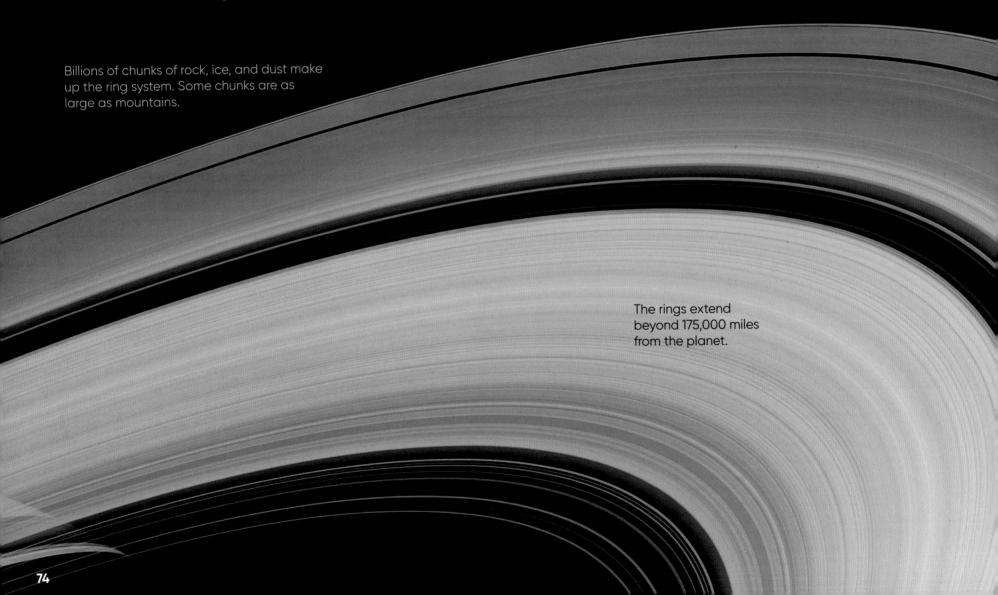

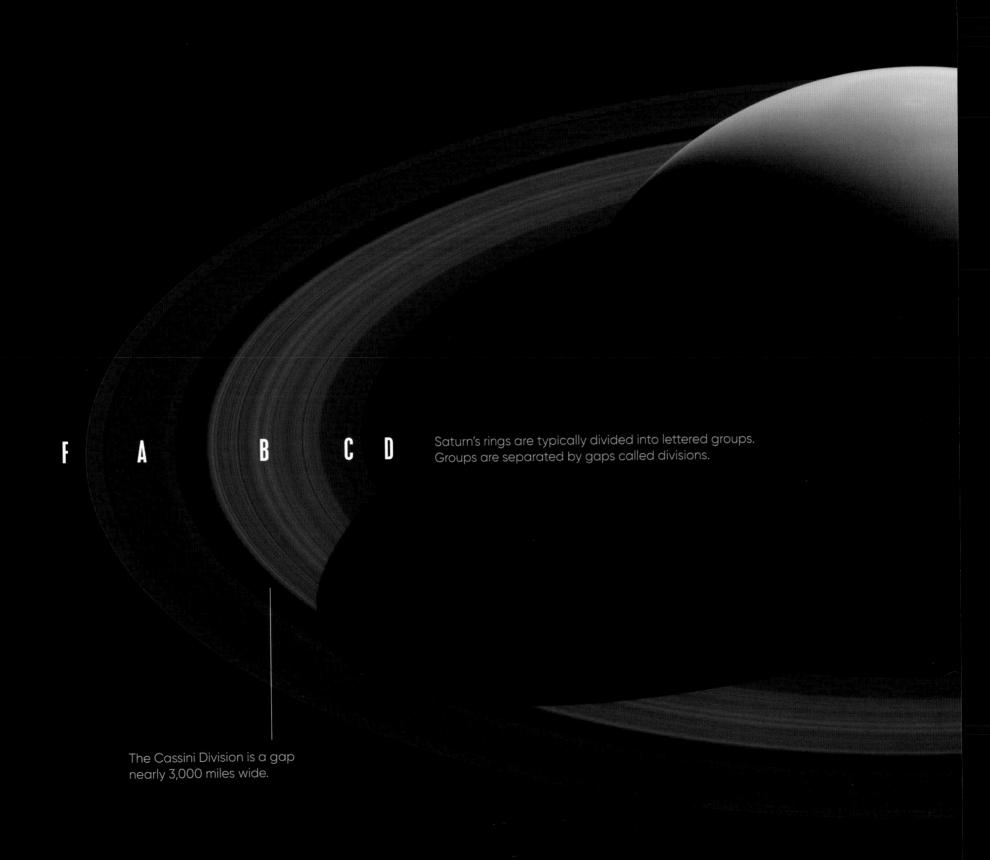

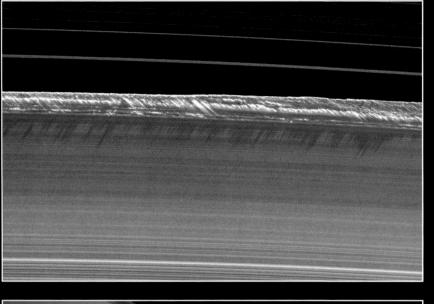

Unusual vertical structures rise from the edge of the B ring, casting shadows inward. Over a mile in height, these oddities in the ring plane may be the result of disruption due to the pull of moonlets and other large objects orbiting nearby.

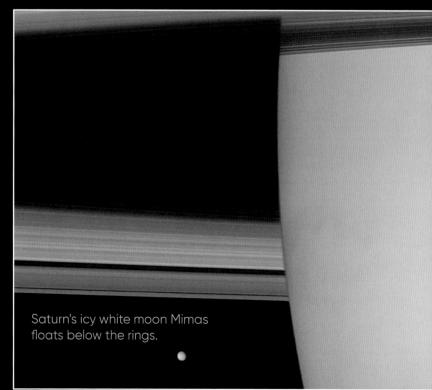

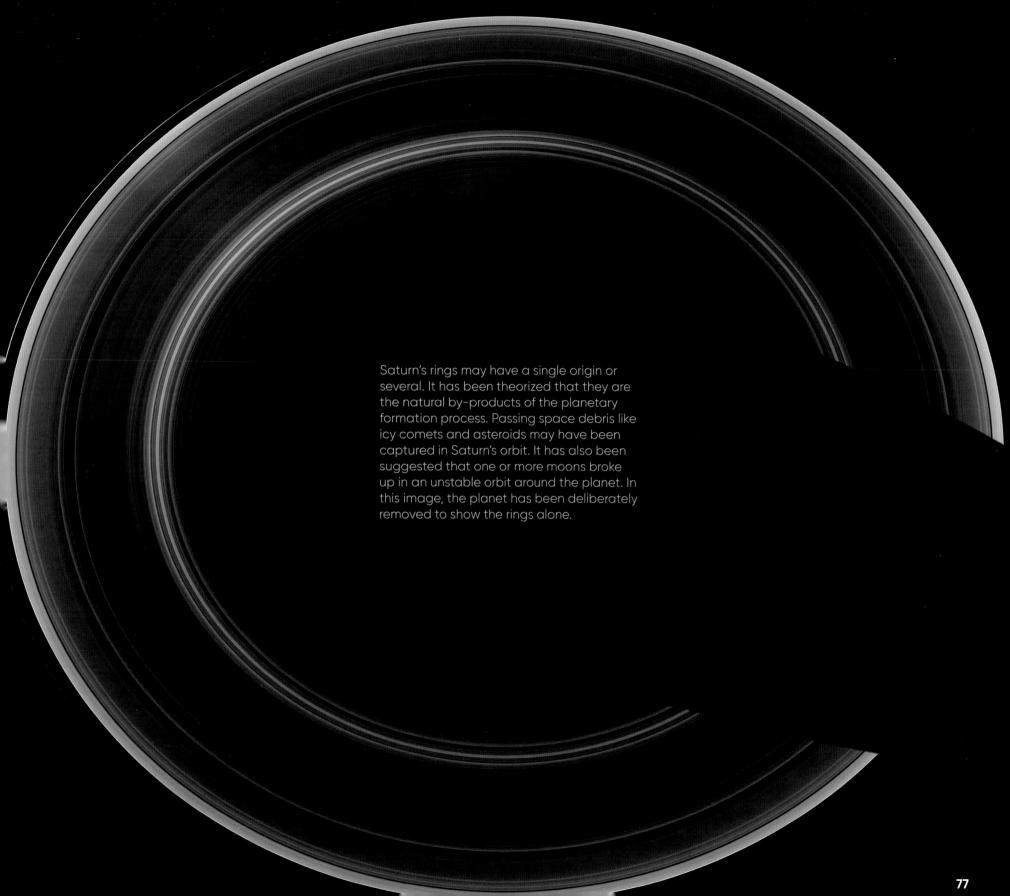

SATURN'S MOONS

The Cassini spacecraft captured this image of three of Saturn's moons in 2011. Rhea is in the center, Dione is to the left (partially blocked by the dark horizon of Saturn), and Enceladus is to the right.

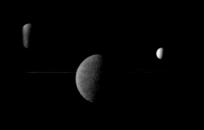

Cassini's flyby in 2004 showed Phoebe to be a rough-looking icy rock. Astronomers speculate that it may have originated in the Kuiper belt.

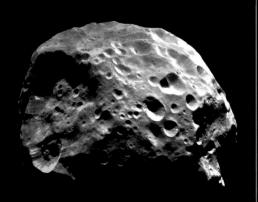

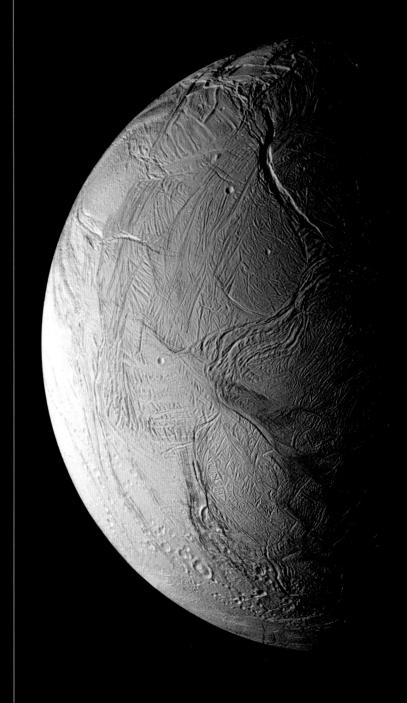

Cassini got a close look at Enceladus when it passed within 15 miles of the moon's surface in 2008.

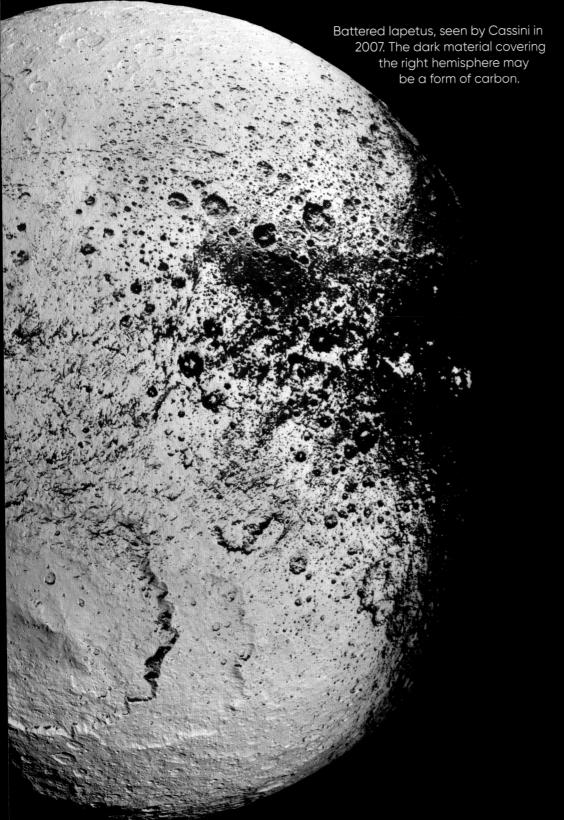

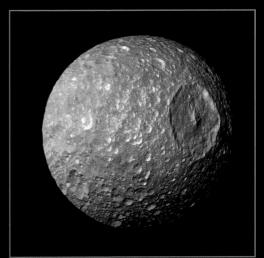

The large Herschel Crater dominates this view of Mimas, taken by Cassini in 2010.

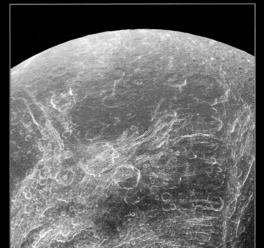

In this closeup view of Dione in 2015, Cassini discovered bright white lines etched into the surface. They represent icy cliffs along stress fractures in the moon's crust.

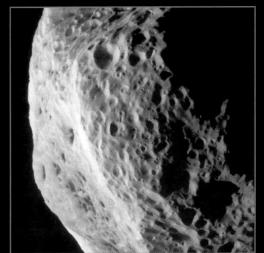

Hyperion is a small, spongy, irregularly-shaped moon that rotates chaotically as it orbits Saturn. Cassini took this image in 2005.

In January 2005, the Cassini mission dropped the Huygens probe onto the surface of Titan, Saturn's largest moon. The probe discovered a fascinating place: unlike any other moon in the solar system, Titan has a thick and opaque atmosphere. It is composed mostly of nitrogen, with some methane and traces of other compounds. It is the only place in the solar system besides Earth to have surface liquids in the form of lakes and rivers.

Titan is larger than the planet Mercury. Below the atmosphere and frozen crust lies a liquid ocean. This subsurface environment fascinates scientists because it could possibly harbor life. The traces of methane in Titan's atmosphere are tantalizing because methane is a telltale metabolic signature of many organisms. Where is the methane coming from? And since sunlight gradually destroys the methane, how is Titan's supply being replenished?

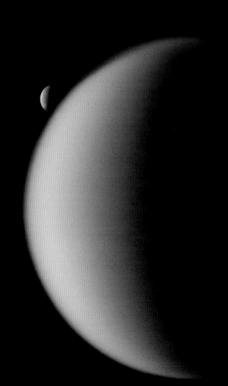

Titan's smoggy atmosphere contrasts with that of other moons. Here, icy Tethys can be seen dipping behind the moon's hazy horizon. Cassini captured the image in 2009.

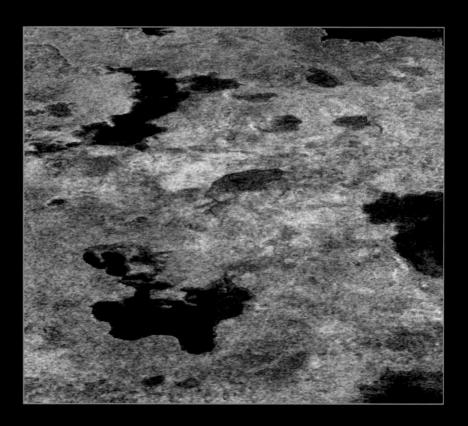

Titan's unique features include liquid lakes. This 2007 image taken during a Cassini flyby captures a partially liquid terrain. The lakes may be liquid methane.

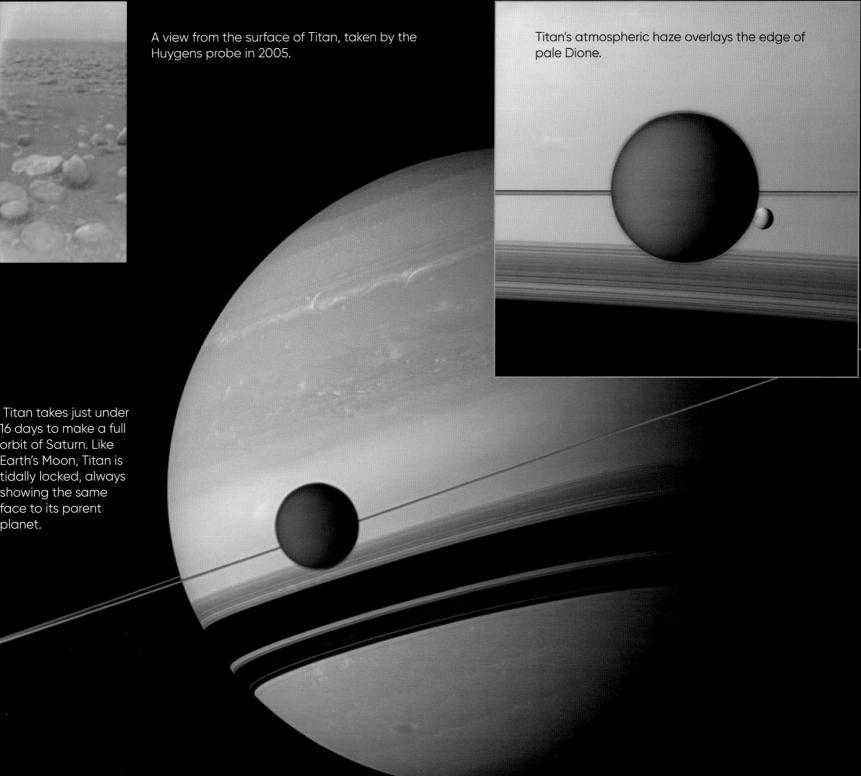

URANUS

Voyager 2's images of Uranus reached us in 1986. Even from a distance of 50,600 miles, the images revealed a near-featureless greenish-blue orb. It has a typical gas giant atmosphere—mostly hydrogen and helium—but also has enough methane to give it its unique tint. Unlike any other planet in the solar system, Uranus rotates on its side.

Voyager 2 also sent us images of a number of moons, revealing a variety of icy worlds, some with notably fractured and uneven surfaces. No spacecraft has visited the system since then.

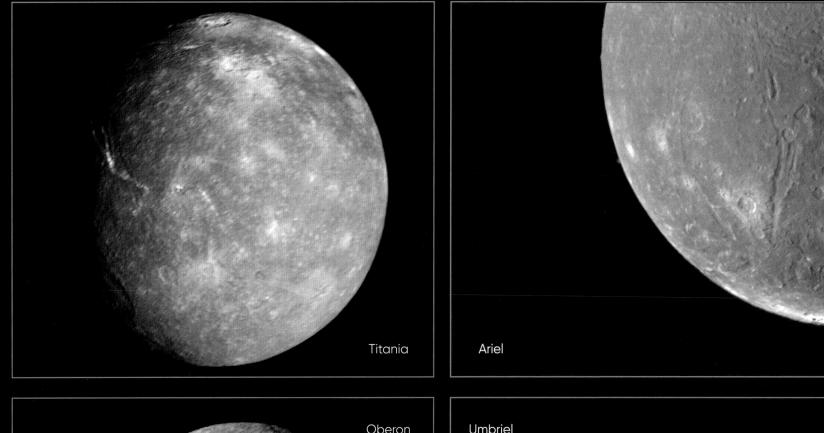

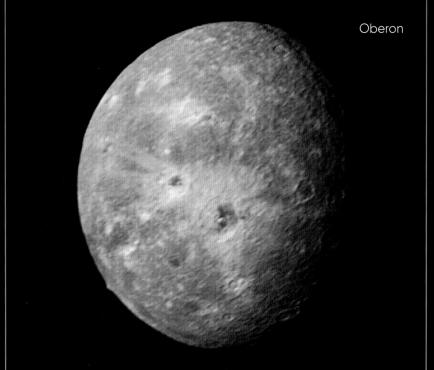

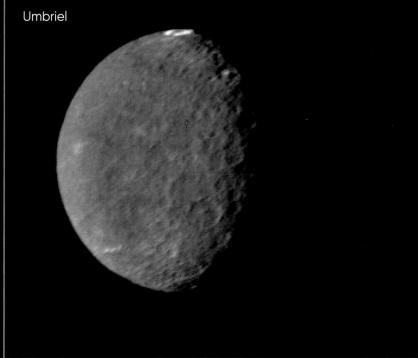

Voyager 2's last stop in the solar system was the gas giant Neptune. From Earth, Neptune appears to be a dim blue world. The mysterious planet had some surprises for us. The first was that the blue world has winds in its outer layer that move at over 1,000 miles per hour. In fact, the winds on Neptune are the fastest in our solar system. The planet also has different-colored bands that are nearly as pronounced as those on Jupiter. The Voyager mission also sent us back images of storms on the planet that look similar to the Great Red Spot of Jupiter.

Voyager 2 confirmed that Neptune has a very thin ring system. These rings are so thin that they are nearly invisible from Earth. The biggest surprise of all was Neptune's moon Triton. Images showed dark eruptions on the surface that looked a lot like geysers. Scientists later determined these were eruptions of nitrogen from beneath the icy polar caps.

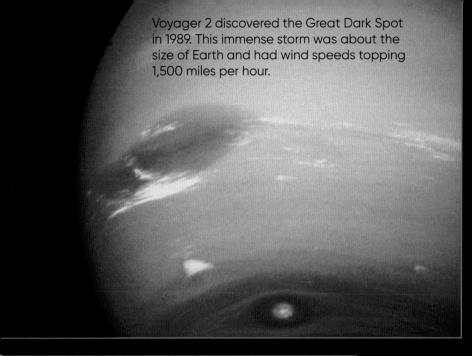

Voyager 2 took this image of streaking cloud bands when it was two hours away from its closest approach to the gas gian

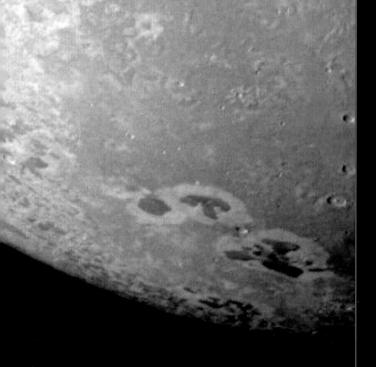

Voyager 2 took this image of Neptune's largest satellite, Triton, in 1989.

Valcanic plains predominate in this close view of Tritor

DWARE PLANETS

Astronomer Clyde Tombaugh discovered Pluto in 1930. In more recent years, researchers have found many problematic bodies in our solar system. Scientists were faced with either assigning planetary status to many more bodies or reclassifying Pluto. In 2006, the International Astronomical Union stipulated that planets have to fulfill the following criteria:

- 1. The body must orbit the Sun.
- 2. The body must be big enough for gravity to quash it into a round ball.
- 3. The body must have cleared all other debris (including asteroids and comets) out of its orbit.

Pluto was reclassified as a dwarf planet because it did not fulfill the third criterion. The reclassification was controversial to some astronomers, however. Many contend that Earth, Mars, Neptune, and Jupiter have not cleared their orbits either. Pluto actually ventures into Neptune's orbit at times, and there are 10,000 asteroids in Earth's orbit and 100,000 in Jupiter's. The debate continues.

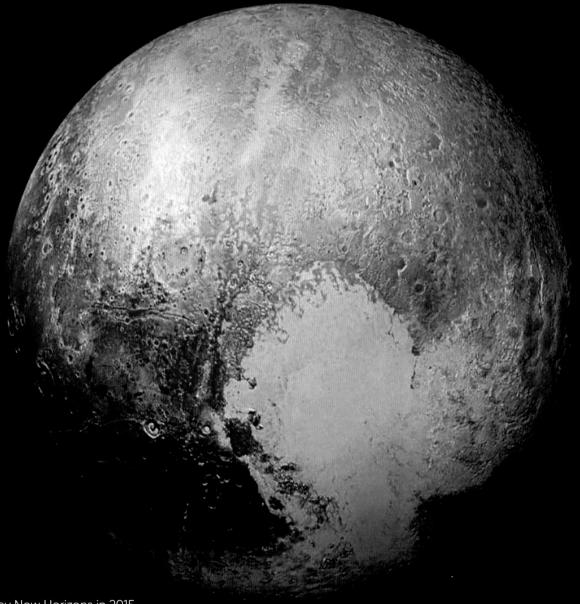

Color-enhanced global view of Pluto, taken by New Horizons in 2015.

Astronomers are aware of dozens of other dwarf planet candidates, and the number is expected to grow. As of 2014, the International Astronomical Union (IAU) recognizes five dwarf planets (Pluto, Eris, Ceres, Haumea, Makemake), with some astronomers asserting this number should be higher. Other notable dwarf planet candidates are:

Quaoar Sedna Orcus 2002MS4 Salacia

2007 OR10

to be dwarf planets, and nearly 200 more that seem to have a high probability of being dwarf planets. There may in fact be thousands more in and beyond the Kuiper belt.

There are 26 additional objects which are highly likely

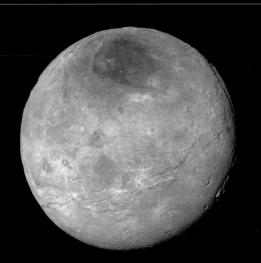

Pluto's moon, Charon, features more geological complexity than might be expected: unusual mountains, sunken plains, and vast tectonic fracture lines.

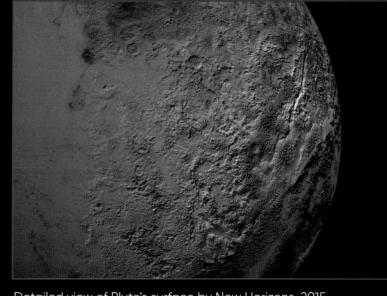

Detailed view of Pluto's surface by New Horizons, 2015.

Ice plains made of nitrogen run into a chain of mountains to the north. The peaks are covered in frozen methane. This view was taken by New Horizons at a range of only 21,000 miles.

COMETS

Seen from Earth, comets are some of the most extraordinary and transient spectacles in the night sky. But comets are more bluster than substance. In reality, they're just big snowballs made up of rock and dust particles, frozen gases, and ice. Their showy tails are the result of sunlight heating them up as they get nearer to the Sun. These tails can stretch out for millions of miles.

Comets are bits of leftover construction material from the early days of our solar system's creation. Some originate in a vast belt of material beyond the orbit of Neptune. These "short-period" comets take less than 200 years to orbit the Sun. Others, originating farther out in the Oort Cloud, can take literally millions of years to make a single orbit.

The comet NEAT was photographed by the Kitt Peak National Observatory in 2004.

SIMPLE CONSTRUCTION

At its center, a comet contains a nucleus. This tiny frozen core may be no more than a mile across. It is made up of icy chunks mixed with rock, gas, and dust. As the comet approaches the Sun, it develops a second part, called a coma. The coma is a cloud of neated gases. These gases typically consist of water vapor, ammonia, and carbon dioxide. As the comet's orbit brings it ever closer, t grows its final two parts, the dust tail and ion tail. The dust tail is composed of gas and dust. The ion tail is a stream of ionized gases that are blown away from the Sun as they the comet comes in contact with the solar wind.

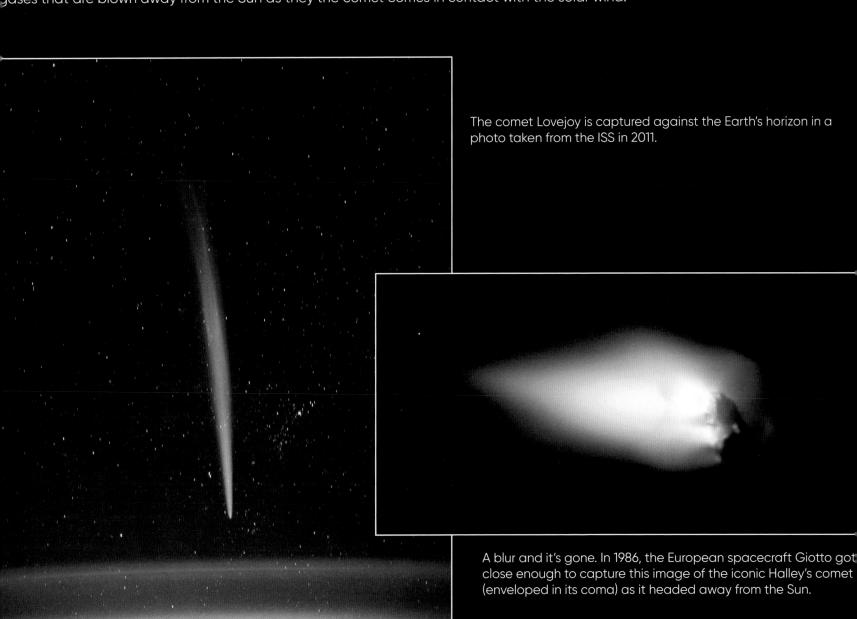

LANDING ON A COMET

The European Space Agency's Rosetta mission was launched in 2004. It was the first mission to successfully land a probe on a comet. The target comet was 67P/Churyumov-Gerasimernko. The controlled impact occurred in 2016.

The landing was complicated by the fact that the comet was shaped like two lopsided balls, with a smaller mass joining them. The flight team carefully maneuvered the spacecraft closer and

deployed the lander. Seven hours later, contact with the comet was confirmed. Unfortunately, the lander bounced. It drifted across the comet's surface before halting against a cliff face. Even so, the mission was able to initiate its science sequence and send back analyses of soil and gas samples. It found an array of compounds important for the formation of prebiotic material. In other words, we now know that the chemical building blocks of life can be found in comets.

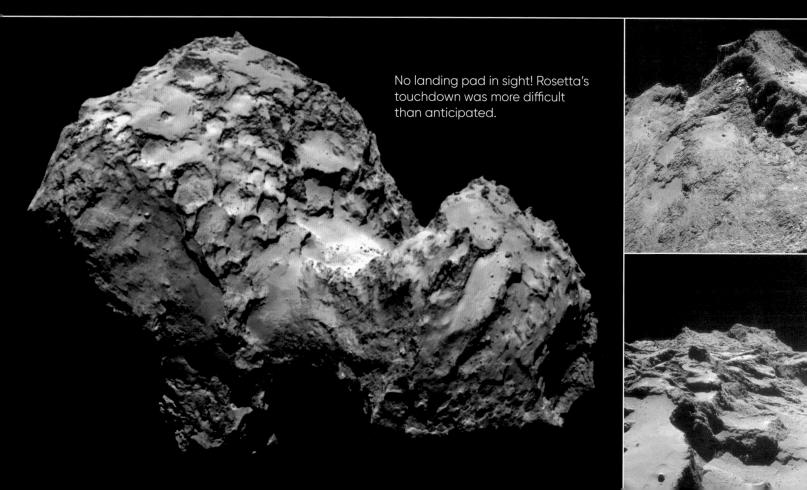

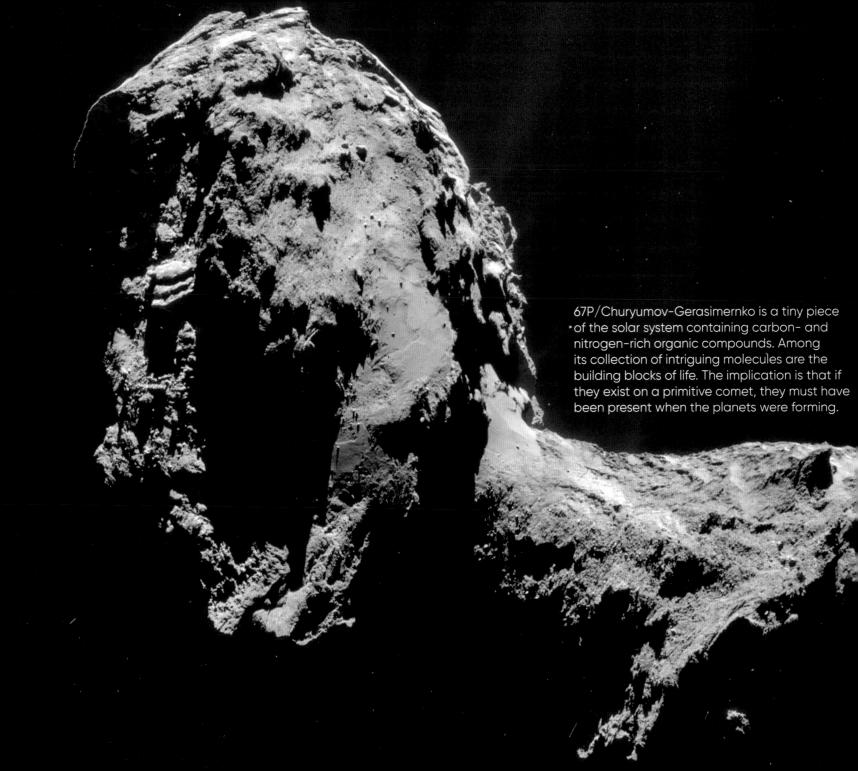

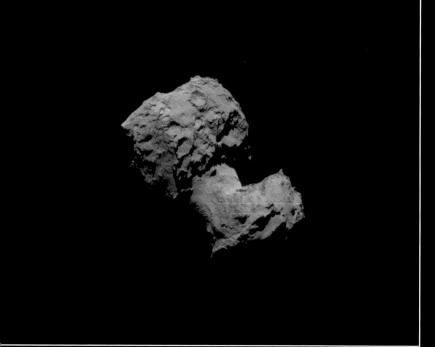

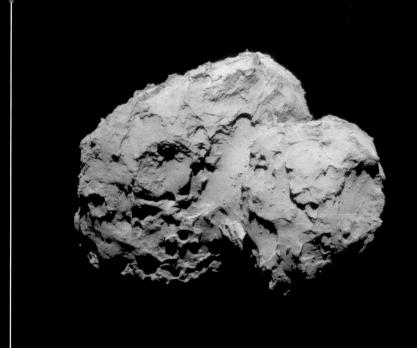

Size and distance can be deceptive when there's nothing familiar nearby to help determine scale. 67P/Churyumov-Gerasimernko is actually several miles across on its long side, making it comparable to a medium-sized Earth mountain.

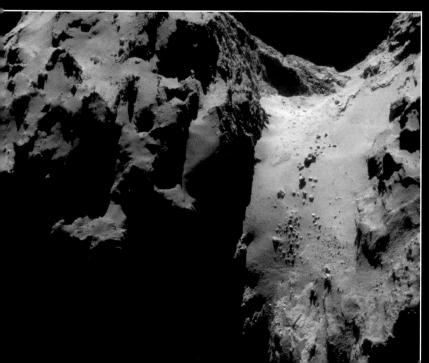

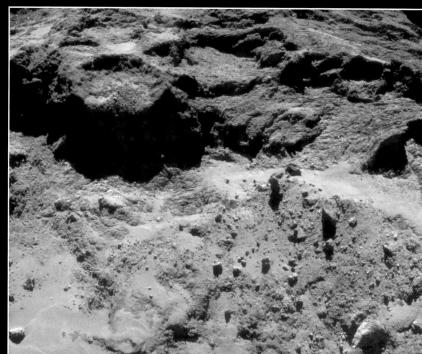

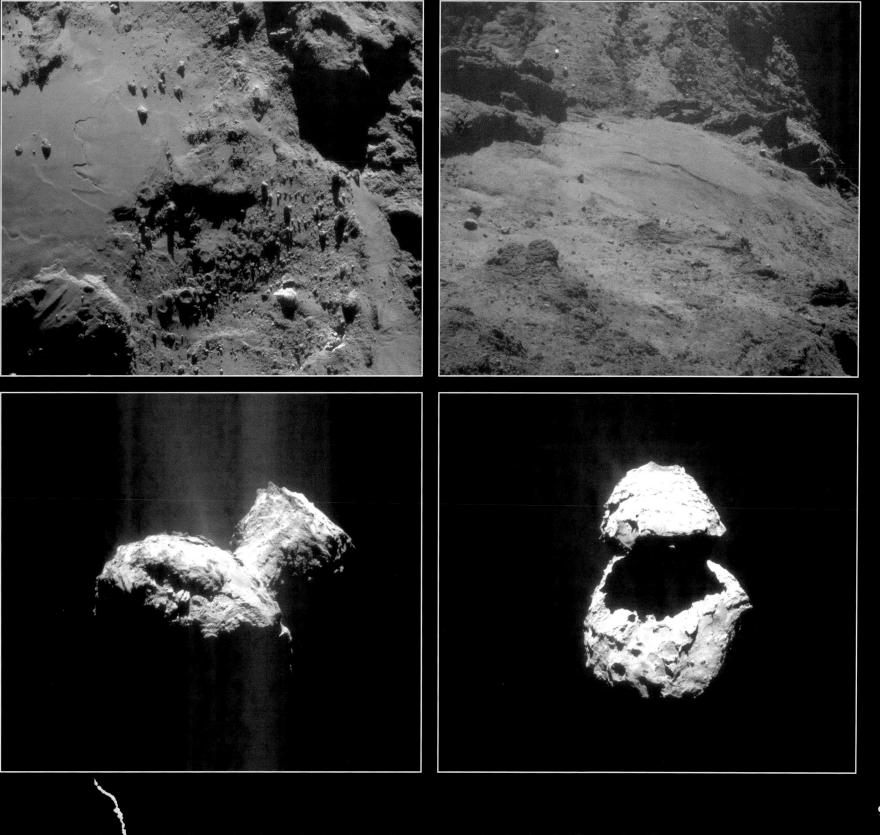

SHOOTING STARS

A meteoroid is a small piece of matter—a chunk of rock or particle of dust—drifting through space. Once this debris enters Earth's atmosphere, it is known as a meteor. Commonly called shooting stars, meteors are very common sights. Anyone who spends enough time staring up into the clear night sky will eventually see one. As a meteor enters the atmosphere, the tremendous friction heats the meteor, causing it to glow and leave behind a trail of bright incandescence.

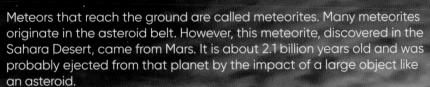

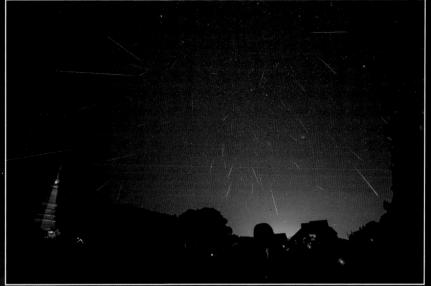

Geminid meteor shower above the skies of Thailand.

THE SUN

The Sun is the largest object in our solar system, accounting for over 99 percent of its mass. It is classed as a yellow dwarf and has an age of roughly 4.5 billion years. The energy that it generates—the heat and light energy that make life on Earth possible—originates from a nuclear fusion process in its core. This energy then moves outward, radiating across the solar system.

The Sun is made up of layers. Outside of the energy-producing core is a vast region known as the radiation zone. In this region, energy slowly moves outward via interaction with surrounding atoms. It is a surprisingly slow process; photons bounce from particle to particle for thousands of years before making their way out of the radiation zone. The next region is the convection zone. This outer layer is cooler, allowing for material to move from hotter to cooler areas. This material follows a direct path outward, meaning that energy is transferred much faster.

The Sun has something like a surface atmosphere as well. This is divided into three regions: the photosphere, the chromosphere, and the solar corona. The photosphere is the visible surface and the area containing observable features like sunspots and granules. Above this, the chromosphere extends upwards for over 1,000 miles. It gradually merges with the corona. Solar filaments and prominences can be seen rising through these top two layers.

The solar wind rises beyond these layers to stream outward in every direction. This wind consists of plasma (charged particles from the corona) and bits of the Sun's own magnetic fields.

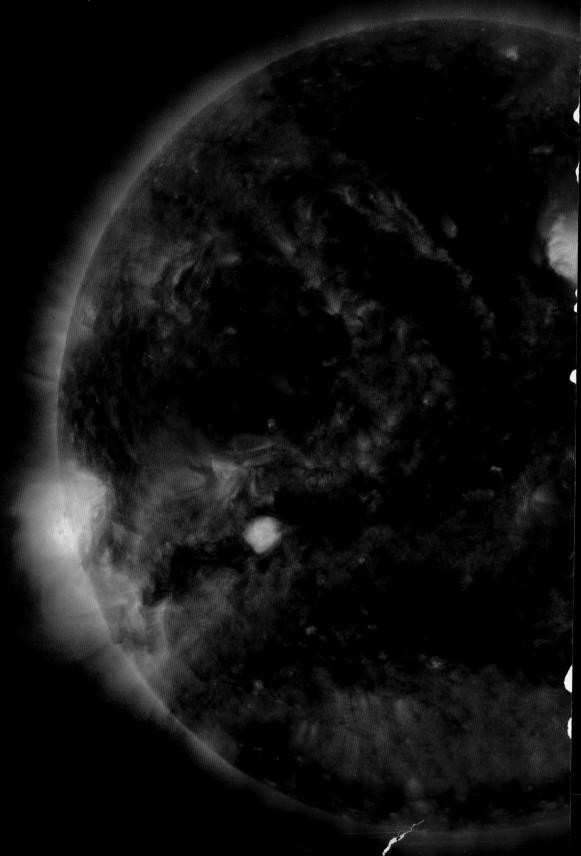

Three telescopes were used to capture the dynamic nature of the Sun's surface: NASA's Nuclear Spectroscopic Telescope Array (NuSTAR) reveals high-energy X-rays in blue, Japan's Hinode captures low-energy X-rays in green, and NASA's Solar Dynamics Observatory (SDO) reveals the rest in yellow and red. The composite image was taken in 2015.

SOLAR FLARES

Solar flares begin with the release of magnetic energy in the solar atmosphere. Huge magnetic loops, called prominences, sometimes collide with each other, setting off a solar flare event. They are often related to sunspot activity. They can last from several minutes to several hours.

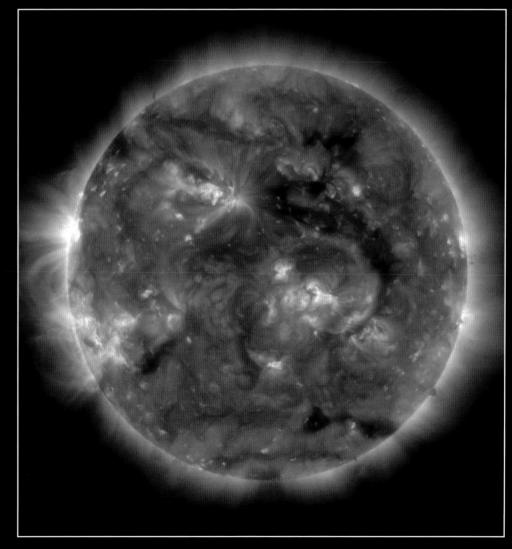

NASA's Solar Dynamic Observatory took this image in 2013. The darkness at the top right of the Sun's face is a coronal hole—the origin of solar wind leaving the Sun.

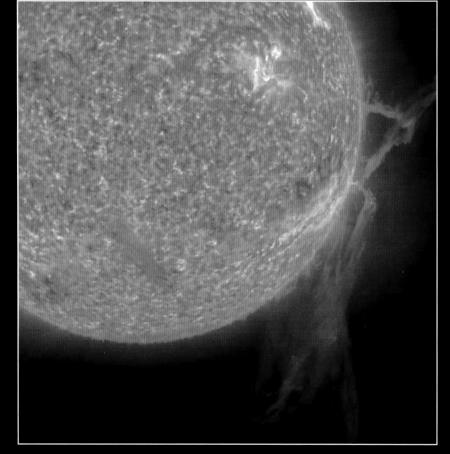

NASA's Solar Terrestrial Relations Observatory (STEREO) caught this image of a massive solar filament snaking around the Sun in 2010.

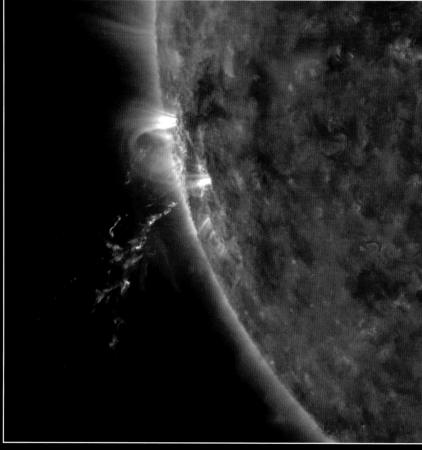

NASA's Solar and Heliospheric Observatory (SOHO) spotted this small solar eruption in 2017. The tempest blew a small stream of plasma out into space.

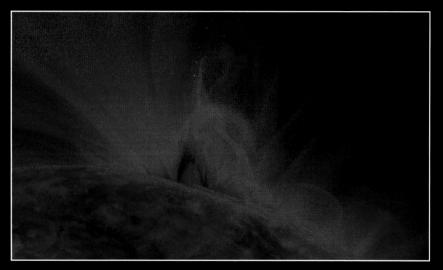

This highly processed image reveals magnetic loops (known as flux ropes) erupting from the surface. SDO captured the event in 2012.

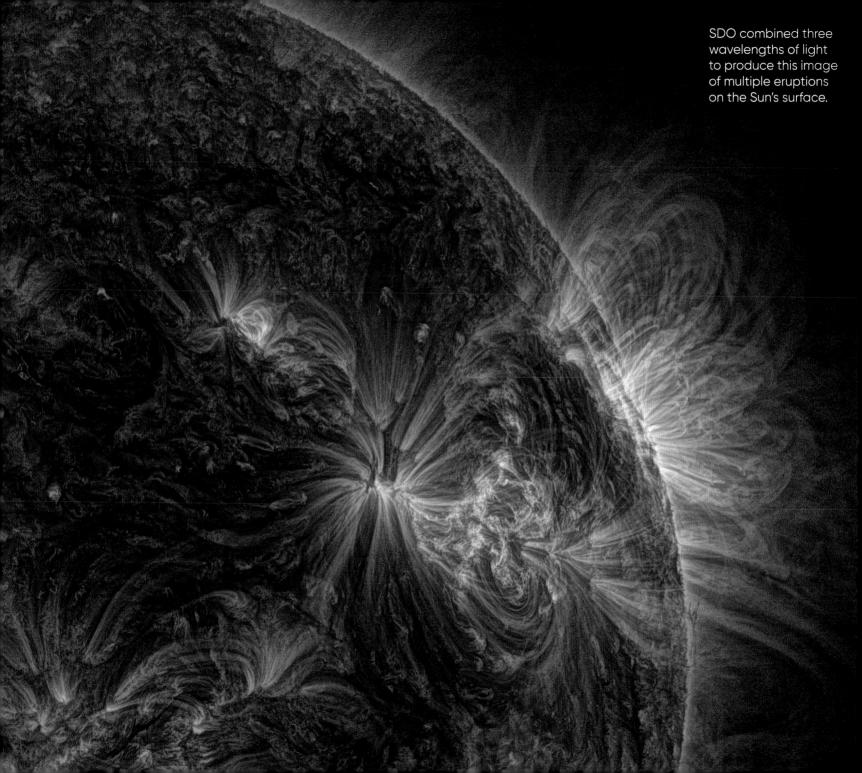

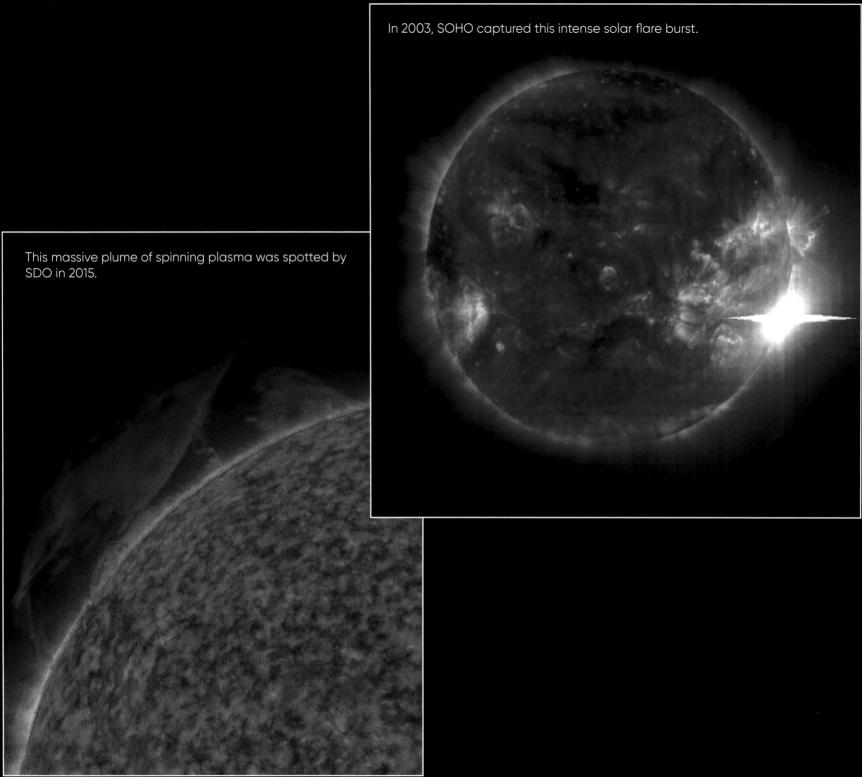

SDO discovered a gigantic sunspot covering almost 80,000 miles of the Sun's surface in 2014. Sunspots indicate the presence of intense magnetic fields. They are prime locations for the outburst of solar flares.

STARS

Stars originate in clouds of interstellar gas and dust. As clouds clump together and attract more mass, they begin to collapse under gravitational attraction and heat up. Eventually they become protostars—hot balls of gas waiting to ignite and become newborn stars. Our Sun went through this process billions of years ago, eventually becoming a yellow dwarf. The Sun is neither the largest, the smallest, nor the most unusual type of

star. Beyond our solar system there are many other star types, some with very surprising attributes.

Astronomers classify stars based on their size, color, temperature and luminosity. The Hertzsprung-Russell diagram is one of the most useful charts for understanding star varieties.

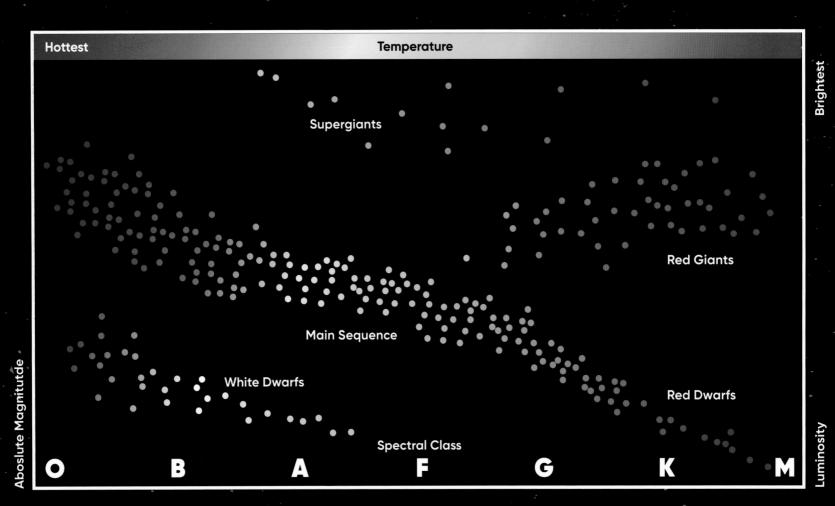

Most stars, including our Sun, are found along the main sequence. Stars tend to spend most of their existence as main sequence stars. Our Sun is a star in the G spectral class.

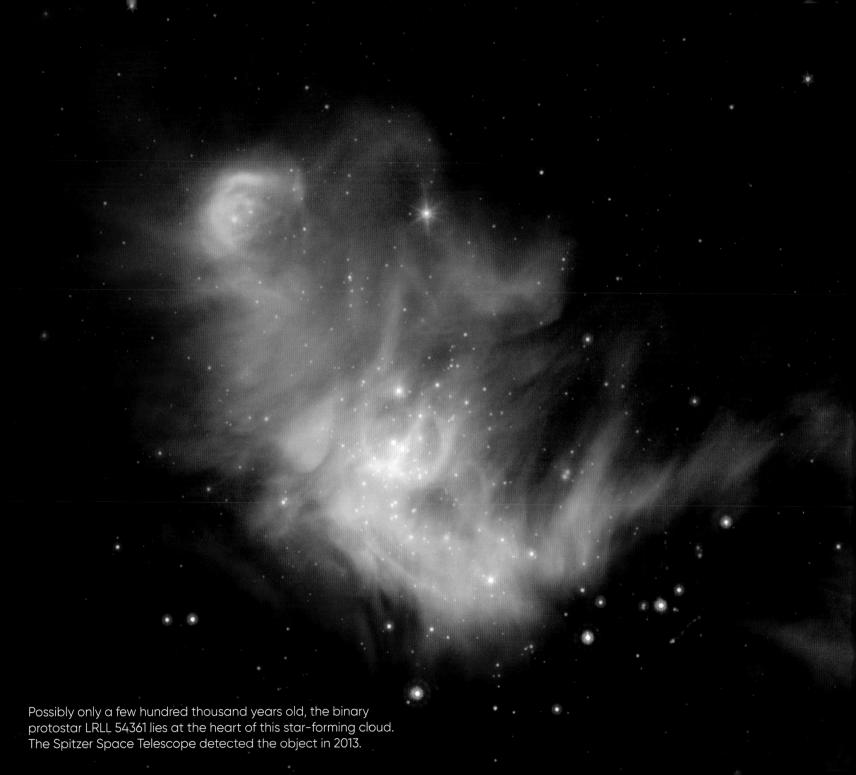

The Hubble Space Telescope zoomed in on this ancient globular cluster in 2004–05. At 13.4 billion years old, this cluster is old enough to have come into being when the universe was young. Old stars predominate: the red stars are giants that expanded as they exhausted their supply of hydrogen. The blue stars have also consumed their hydrogen and are now using helium as an energy source.

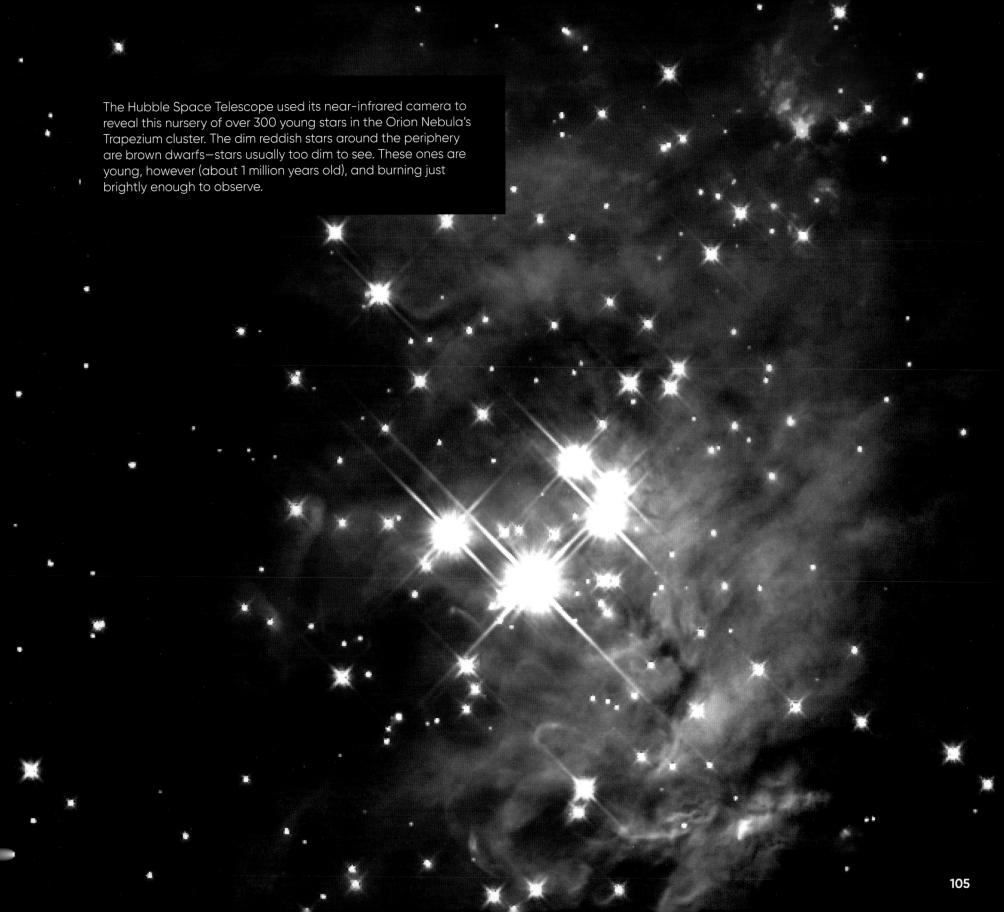

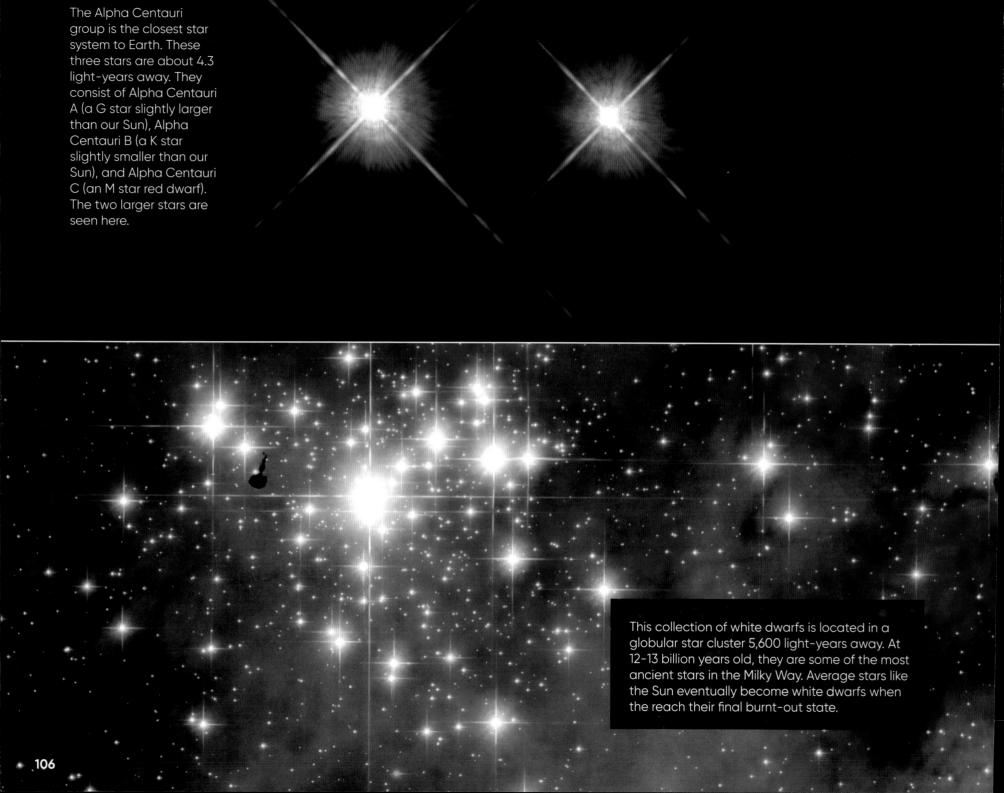

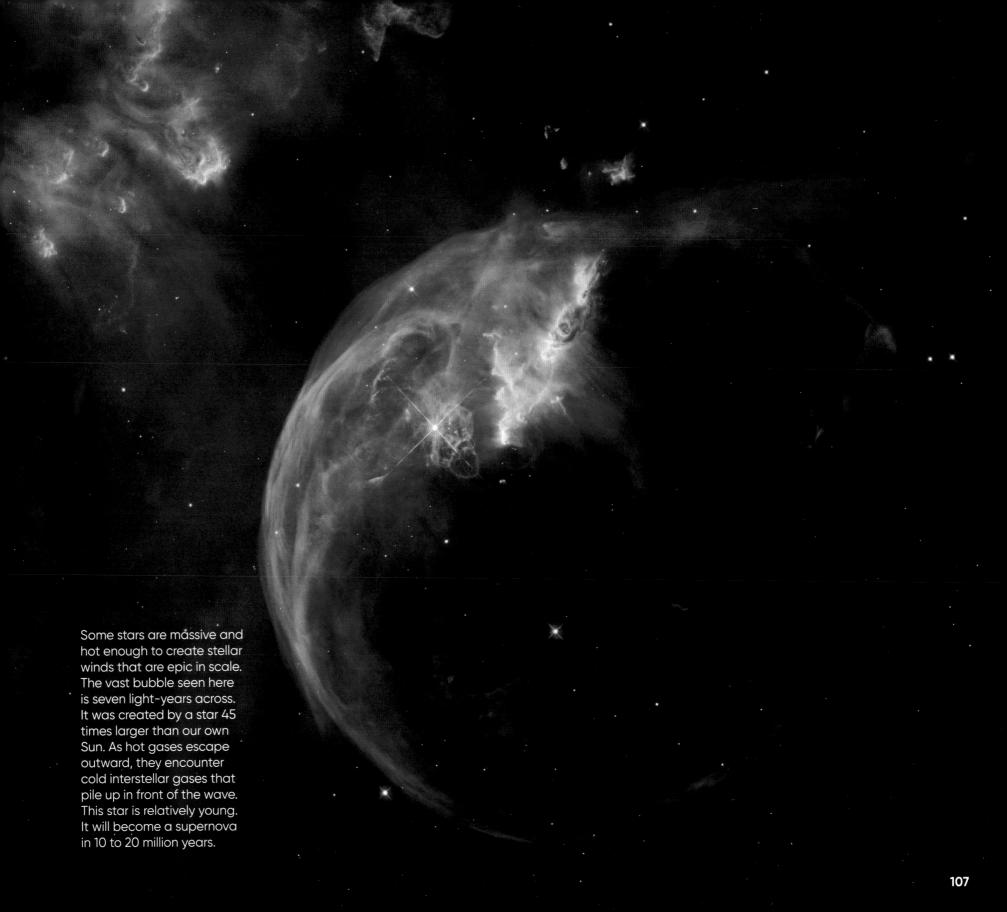

This immense stellar nursery is located in a vast network of gas clouds within the nearby galaxy Large Magellanic Cloud. The area, known as N11, is 1,000 light years across.

3,300 light-years away, a cluster of about 130 young stars is emerging from the nebulous region known as NGC 7129. The remaining gas and dust in the region will continue to supply the raw materials needed for additional star creation.

This colorful old globular cluster is tucked away in the Large Magellanic Cloud. Prominent among the white dwarfs and red giants is a gleaming red carbon star (lower left of the cluster). Carbon stars are usually red giants. These stars appear a deep ruby red to us due to the carbon in their atmospheres. Carbon stars have run out of hydrogen and use helium as their energy source. This produces the carbon and oxygen that passes into the star's outer layers.

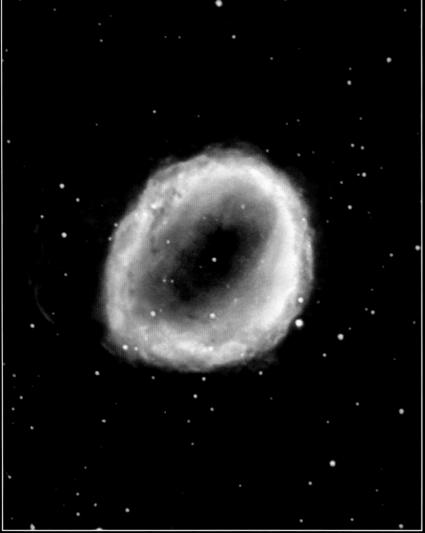

Planetary nebula PK 329-02.2 (also called Menzel 2, after the astronomer, Donald Menzel, who first noted it in 1922) is about 8,000 light-years away.

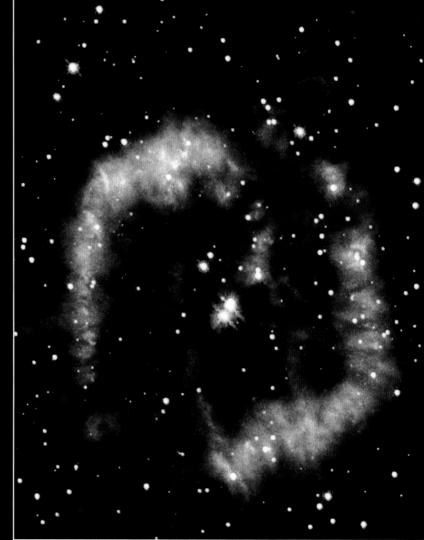

A planetary nebula is simply an expanding shell of luminous gases thrown off by a star. The phenomenon occurs when a star can no longer support itself via fusion in the core. The star suddenly shrinks and thermonuclear reactions move to the star's helium shell.

Outward radiation pressure begins to exceed the inward pull of

Planetary nebula NGC 6565 is estimated to be about 15,000 light-years

away, in the direction of our galaxy's central bulge.

gravity. Once the outer portions of the star begin to separate, they do so in speedy and spectacular fashion. The ejected gas hurtles outward, illuminated from within by radiation from the still-burning star. The remnant star is a white dwarf.

The Calabash Nebula (technically named OH 231.8+04.2) is in the midst of developing a full planetary nebula. This initial phase is quickly over in astronomical terms, taking only about a thousand years.

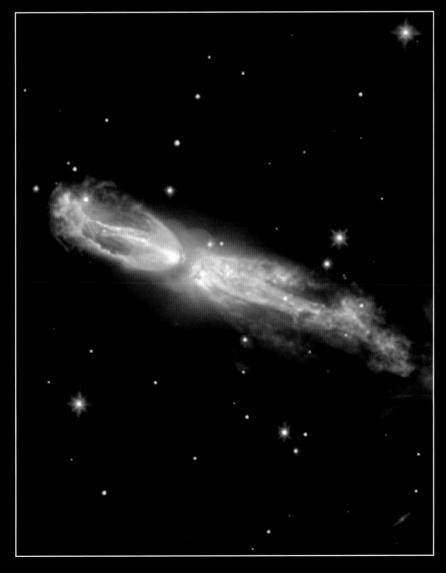

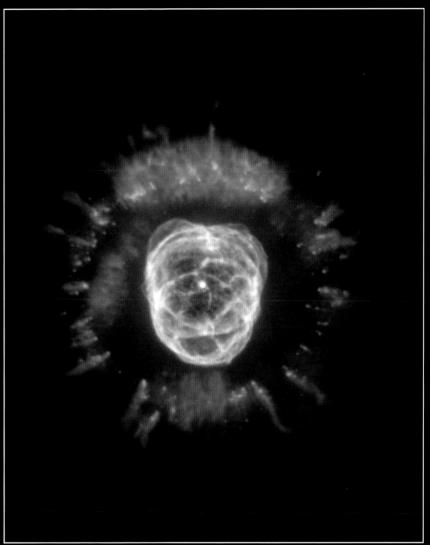

William Herschel named the Eskimo Nebula (technically named NGC 2392) in 1787. From his telescope, the planetary nebula had the appearance of a human head surrounded by a parka hood.

Not all stars make symmetrical transitions. The planetary nebula NGC 5189 probably expanded messily due to an uneven ejection of star mass. 114

The odd shape of IC 4406 is due to our end-on viewing angle. From another point in space, this planetary nebula would appear as a ringshaped cloud of glowing gas.

NOVA OR SUPERNOVA?

A typical nova begins in a binary system. A white dwarf orbiting a larger star begins to siphon that star's outer layer of gas. When enough gas builds up around the white dwarf, a thermonuclear chain reaction occurs. The explosion can cause the system to shine a million times brighter than normal. This outburst can happen multiple times if the white dwarf continues to steal gas.

A supernova is even more violent. A Type Ia supernova also involves a white dwarf stealing gas from a companion star. In this case, the white dwarf's dead core reignites in an explosion that destroys the star. A Type II supernova involves a star much more massive than our Sun. When this star runs out of fuel, it collapses under its own gravity and then explodes. A Type II supernova may leave behind a neutron star, pulsar, or black hole. As data has improved, astronomers have divided Type 1 into 1a, Ib, and Ic. The latter two types involve the core collapse of a massive star.

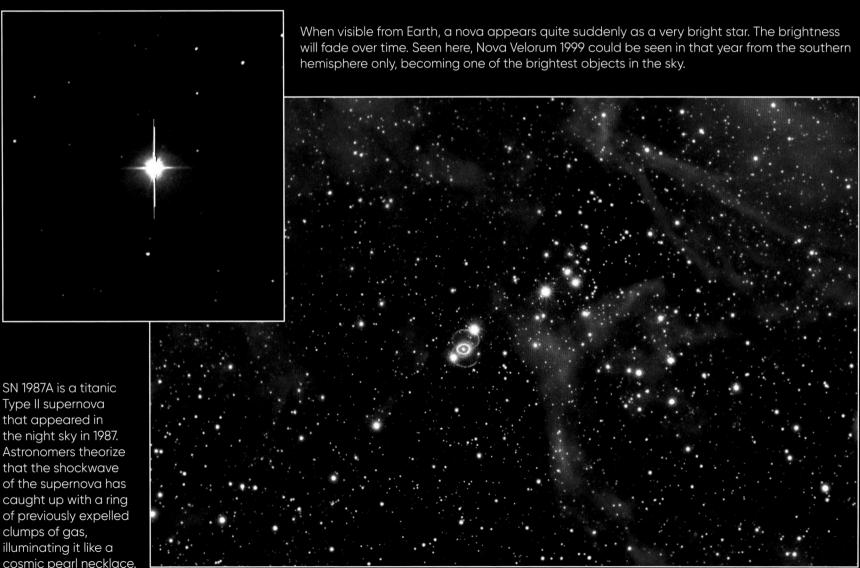

SNR 0519 is about 150,000 light-years away, in the Large Magellanic Cloud. The supernova remnant is fairly young—its progenitor star exploded 600 years ago.

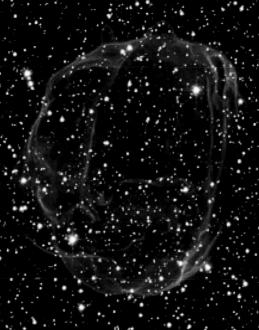

The Homunculus Nebula is a two-lobed phenomenon surrounding the Eta Carinae system. The largest star in the system is near the end of its life and underwent a "supernova imposter event" observed by astronomers in 1843. It stopped short of destroying the star, but at some point in the next million years it will go supernova for real.

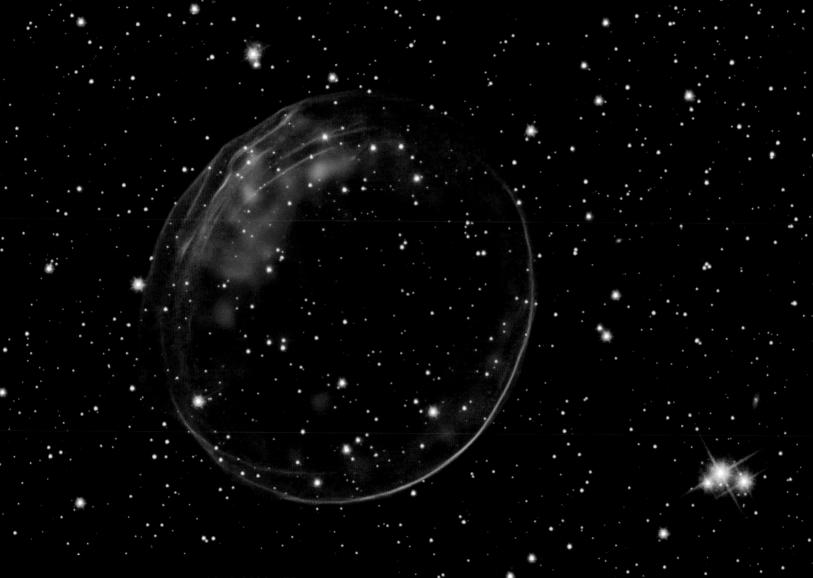

The expanding shock wave of SNR 0509-67.5 appears as a red outline circling greens and blues (representing heated gas). Both the Hubble Space Telescope and the Chandra X-ray Observatory were enlisted to create this composite image. The supernova remnant is about 23 light-years across.

NASA's Chandra X-ray Observatory took this close look at the ejecta around GK Persei, a white dwarf that went nova in 1901. The nebula surrounding the star is called a nova remnant. Nova remnants create less mass and energy than planetary nebulas.

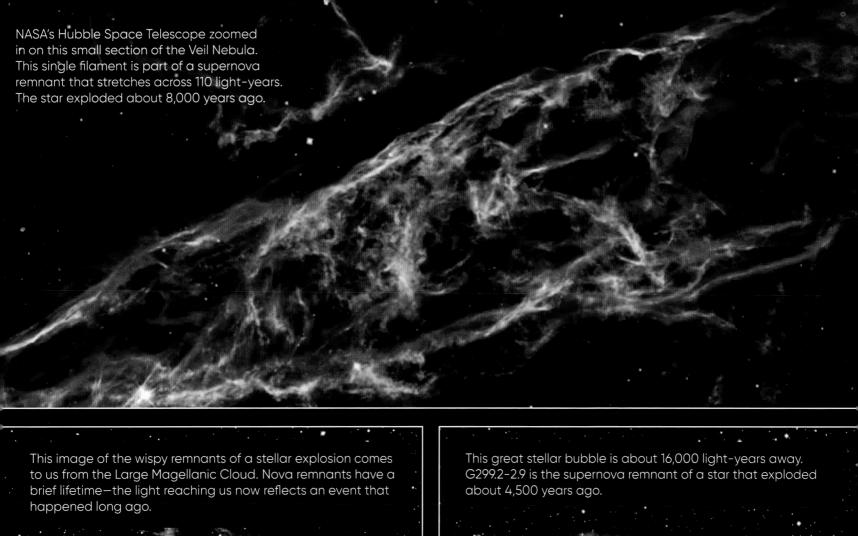

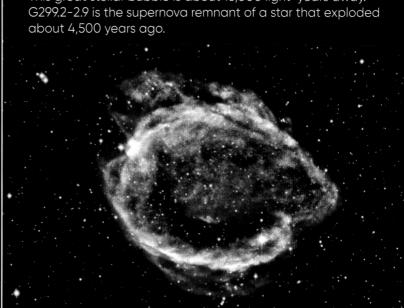

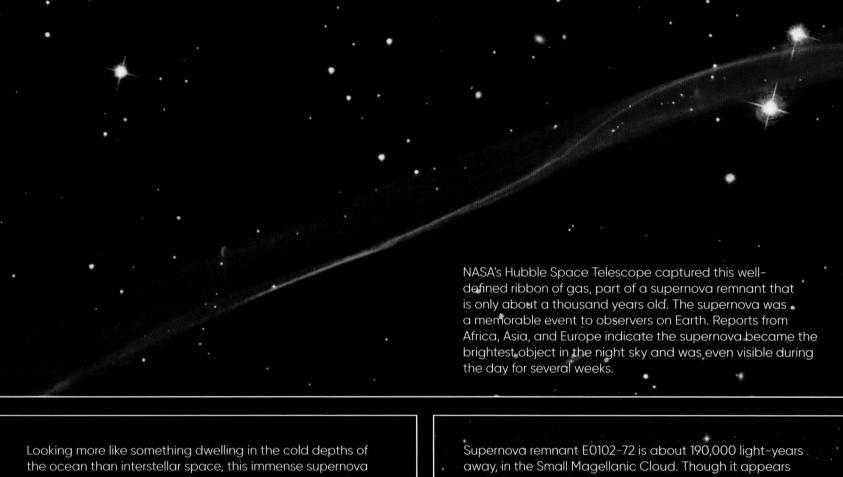

remnant is composed of superheated gas and debris. The expanding shock wave is outlined in blue. We know exactly when the supernova occurred: many observers, including astronomer Tycho Brahe, noted the event in 1572.

perfectly spherical from our perspective, the explosion actually created an unusual cylindrical shape.

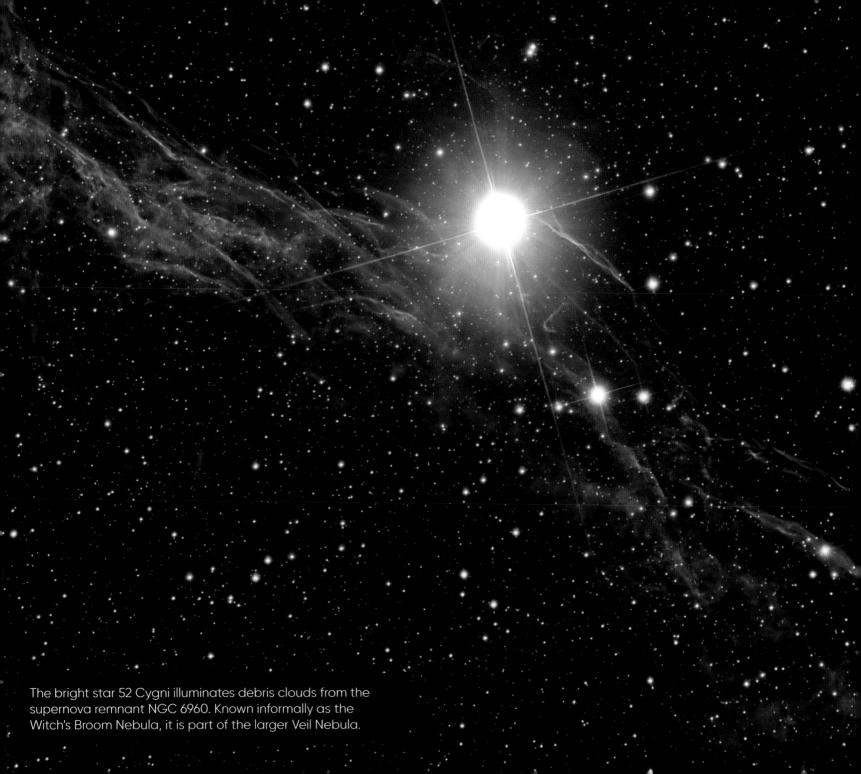

NEUTRON STARS

A star of just the right size will end its life as a neutron star. Once t has exhausted its hydrogen fuel, converted its core to iron, and plown its outer shell in a supernova event, the force of gravity on the collapsing core becomes strong enough to merge electrons with protons. The resultant super-compressed ball of neutrons is about the size of a city.

Neutron stars are unusual stellar objects in many ways. They're some of the most rapidly rotating stellar objects observed in the universe. They have the highest magnetic fields ever observed. The matter they're made of is so condensed that less than a handful would weigh millions of tons.

Since neutron stars are not light-producing via nuclear reactions, we observe them in other ways. Charged particles produce adiation when accelerated by a neutron star's magnetic field. The radiation can appear in the radio spectrum, so the objects

are often observed with radio telescopes. This radiation comes from the neutron star's magnetic poles. The regular spin of the star makes it appear to pulsate with radiation. A neutron star of this type is called a pulsar (short for "pulsating star"). Pulsars emit constant beams of radiation, like lighthouse beacons. Pulsars with extremely powerful magnetic fields may emit X-rays and gamma ray radiation, and so can be observed via X-ray and gamma ray telescopes.

When the first pulsar was discovered, astronomers dubbed it LGM-1—short for Little Green Men-1. The pulses seemed artificial because they were timed so perfectly. Astronomers joked that they were signals from aliens. We now know that pulsars are great timekeepers. They rotate at extremely precise intervals, from once every few milliseconds to once every ten or more seconds.

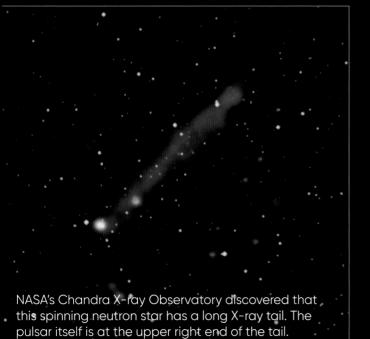

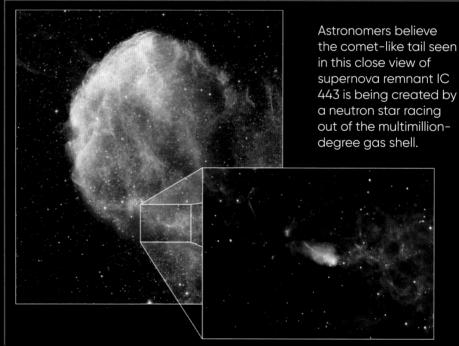

An extremely powerful pulsar lies at the center of the Crab Nebula, beaming jets of charged particles. The Chandra X-ray Observatory captured this image. A bright ring of high-energy particles radiates from the equatorial region of the pulsar.

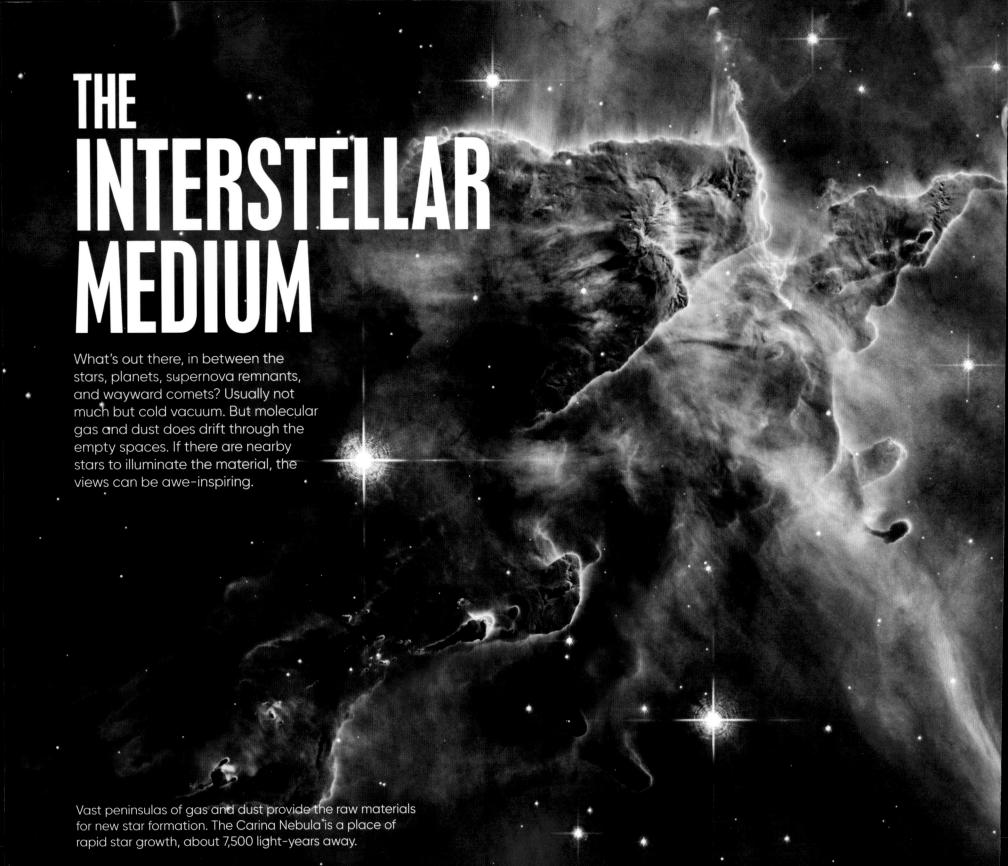

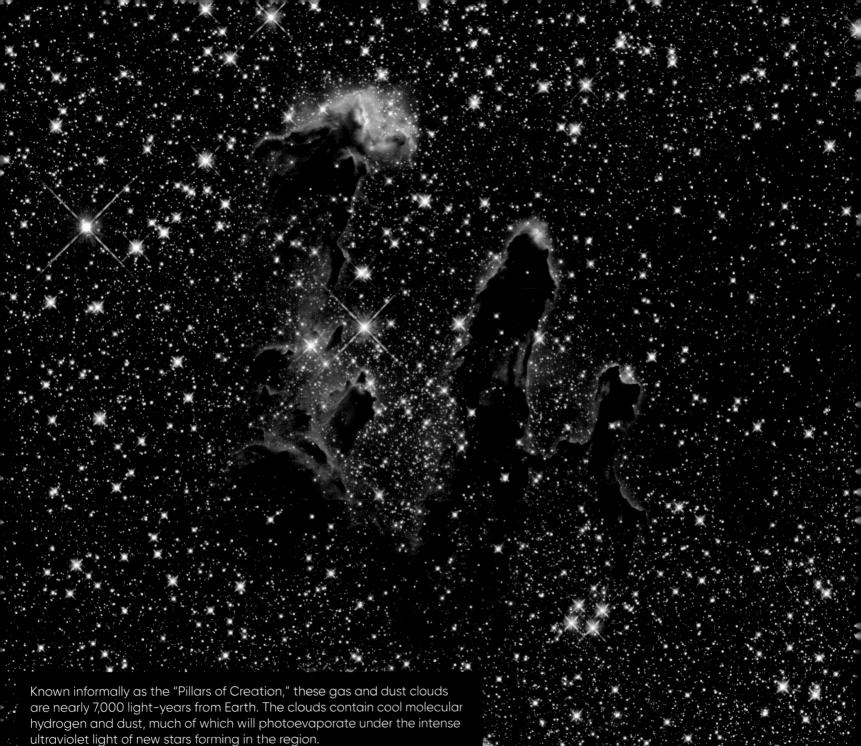

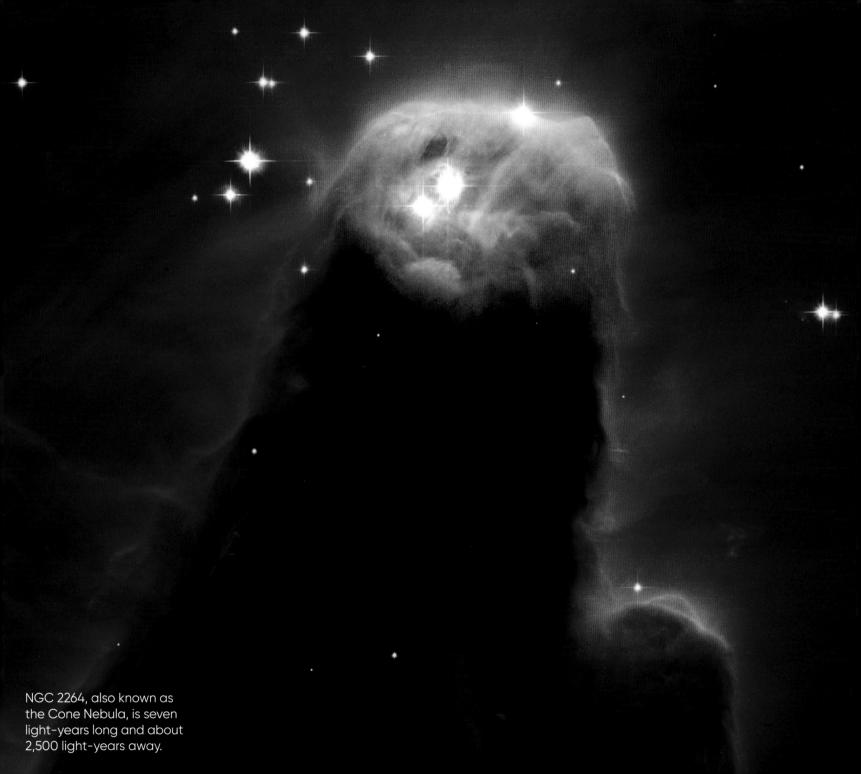

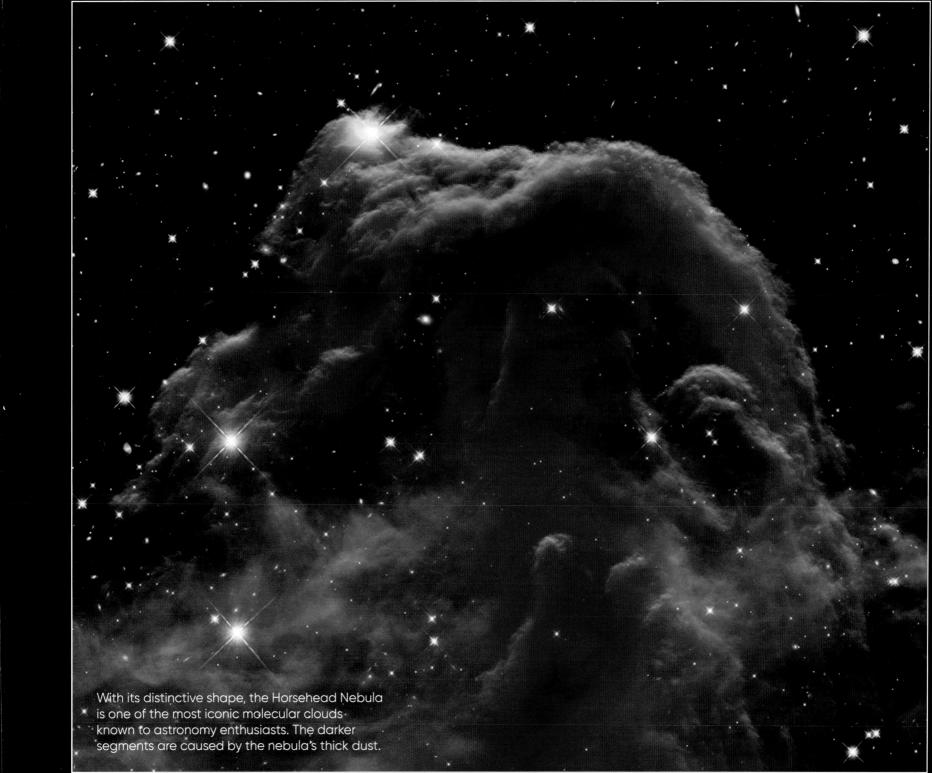

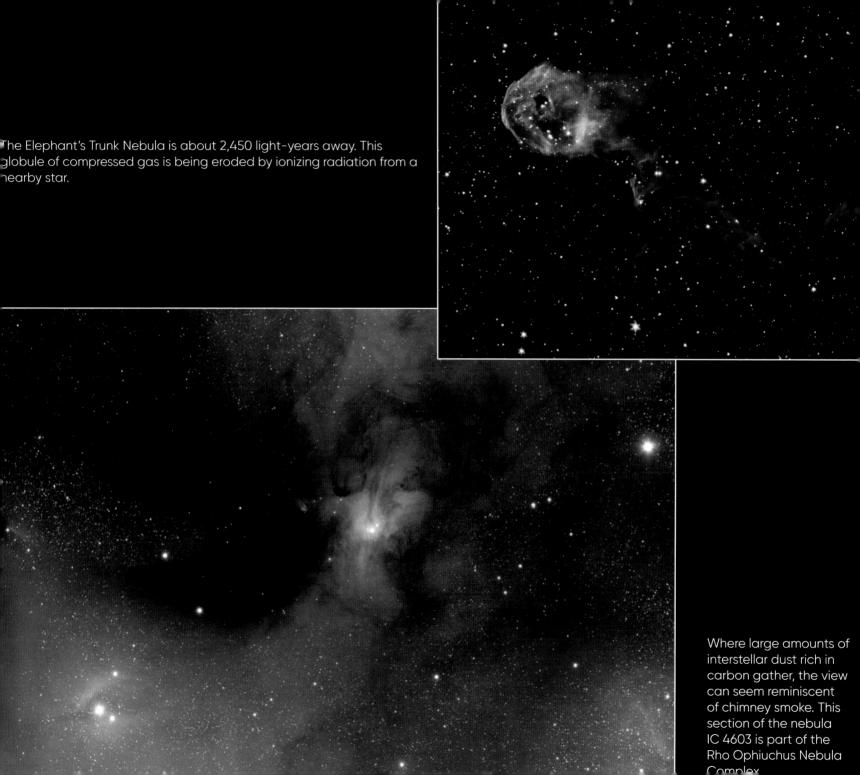

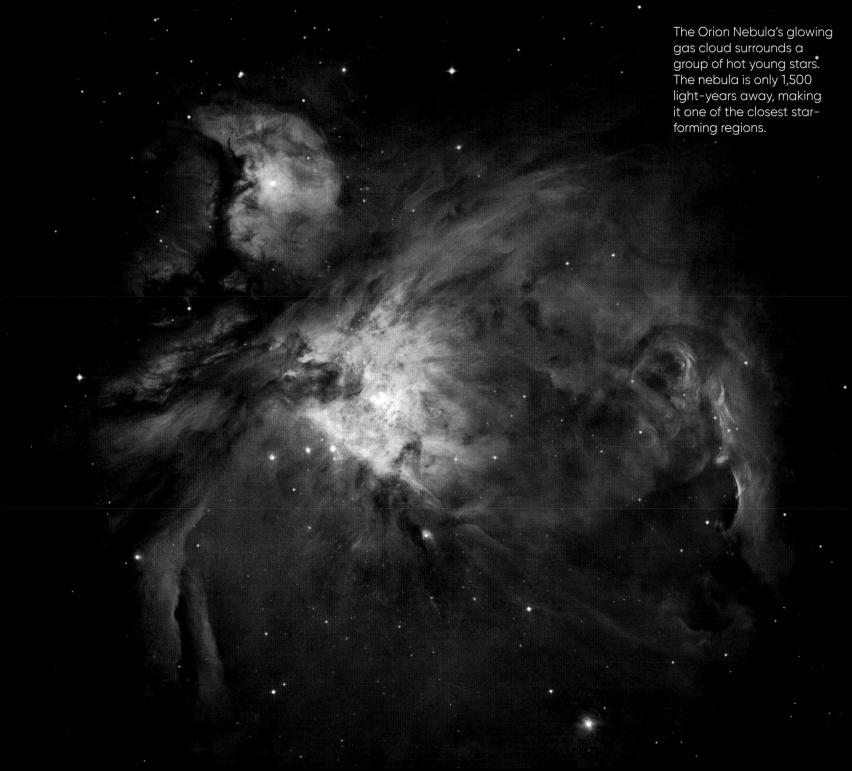

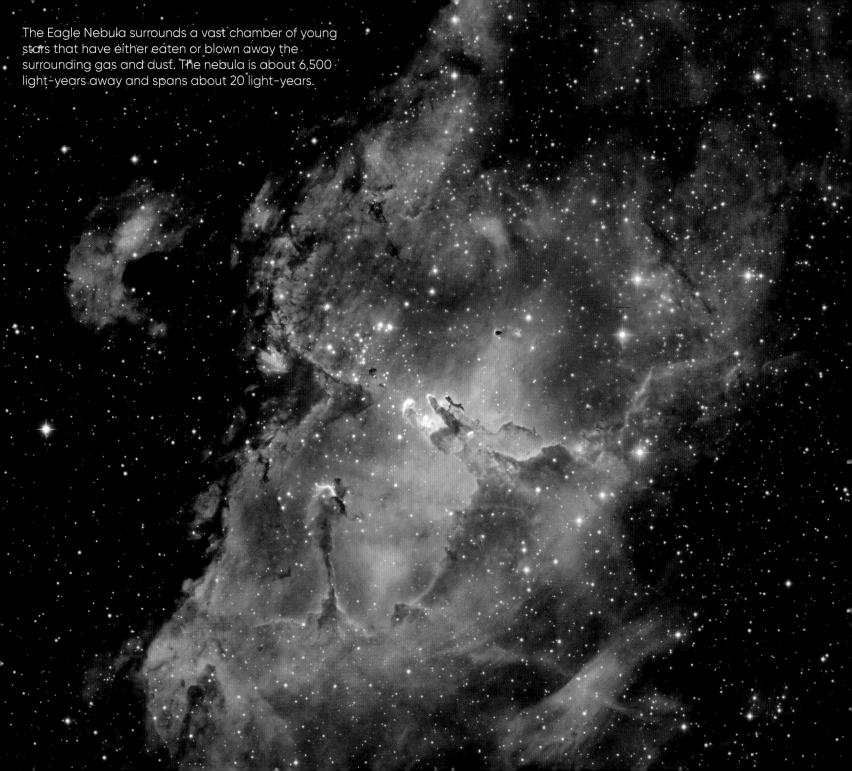

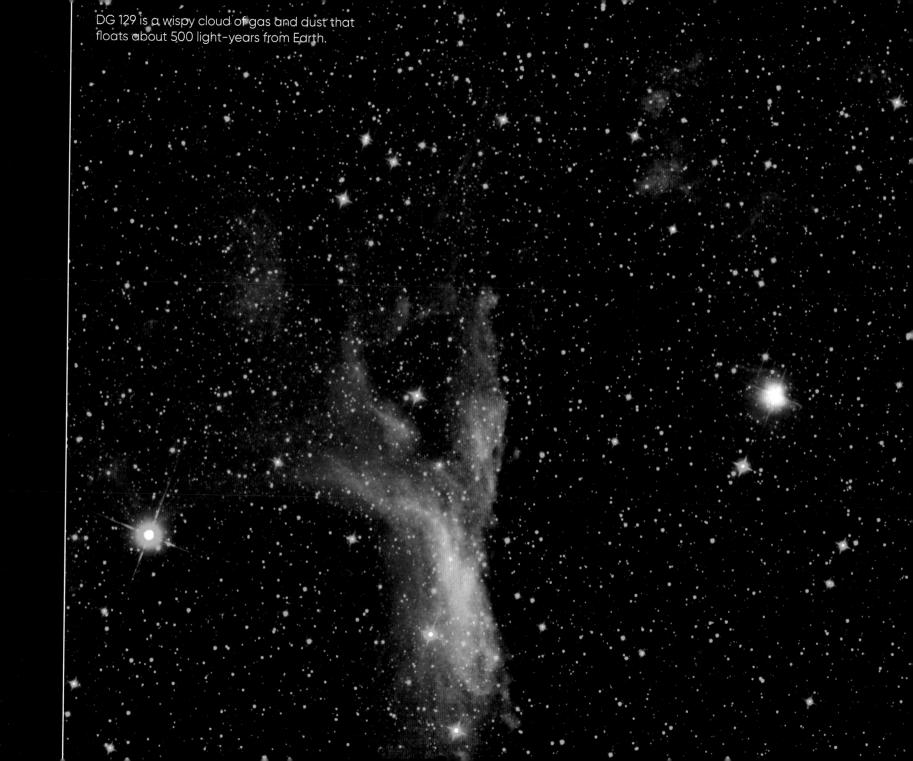

FALAXIES

ur awareness of the nature of galaxies is fairly cent. Early telescopes were able to pick out anets, moons, comets, and stars, but weren't owerful enough to reveal galaxies. Instead, nese objects seemed like small fuzzy smudges. It asn't until the 1800s, when telescopes became rger and more powerful, that those smudges evealed themselves to be swirling colonies f stars that each contained many millions f members. We now know that not only are nere too many galaxies to count, but they are rouped together into clusters and superclusters.

Senerally speaking, there are three types of alaxies: spiral, elliptical, and irregular. A spiral alaxy, like our own Milky Way, looks a lot like a hild's pinwheel toy. A spiral galaxy has a very right center that is packed with stars, gas, ind dust. Spreading out from the center are right arms of dust, stars, and stellar nurseries. Vhen viewed from their edges, spiral galaxies ook almost flat, with a bump in the middle like a ombrero.

Iliptical galaxies are shaped like eggs. They ook like clouds of stars when viewed through a elescope. Elliptical galaxies are thought to be older than spiral galaxies. They usually don't have nany areas where young stars are being born. hey also do not rotate like spiral galaxies do.

rregular galaxies do not fall into either category. hese galaxies have unusual shapes—in some cases the result of being distorted by the pull of a arger galaxy. In other cases, an irregular galaxy may have been reshaped because of a collision with another galaxy.

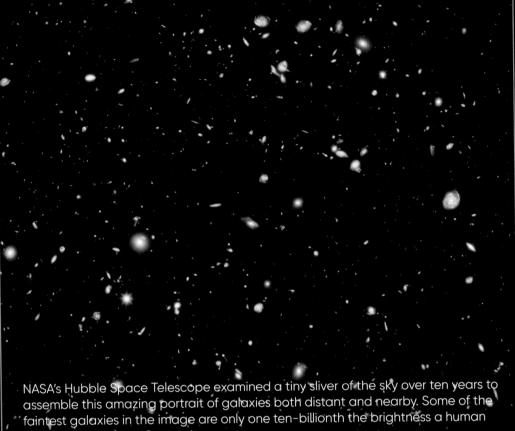

eve can perceive.

NGC 6744 is a spiral galaxy similar in appearance to our own.

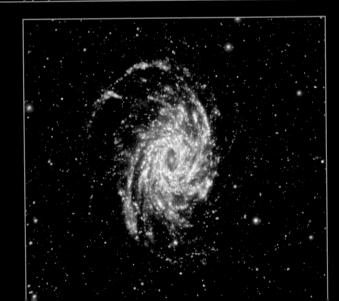

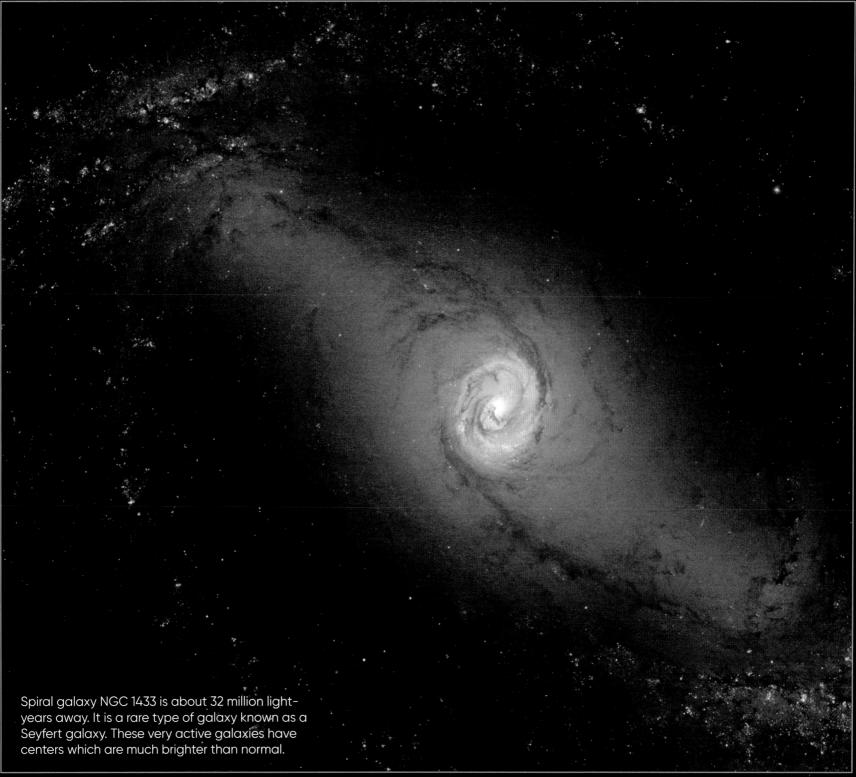

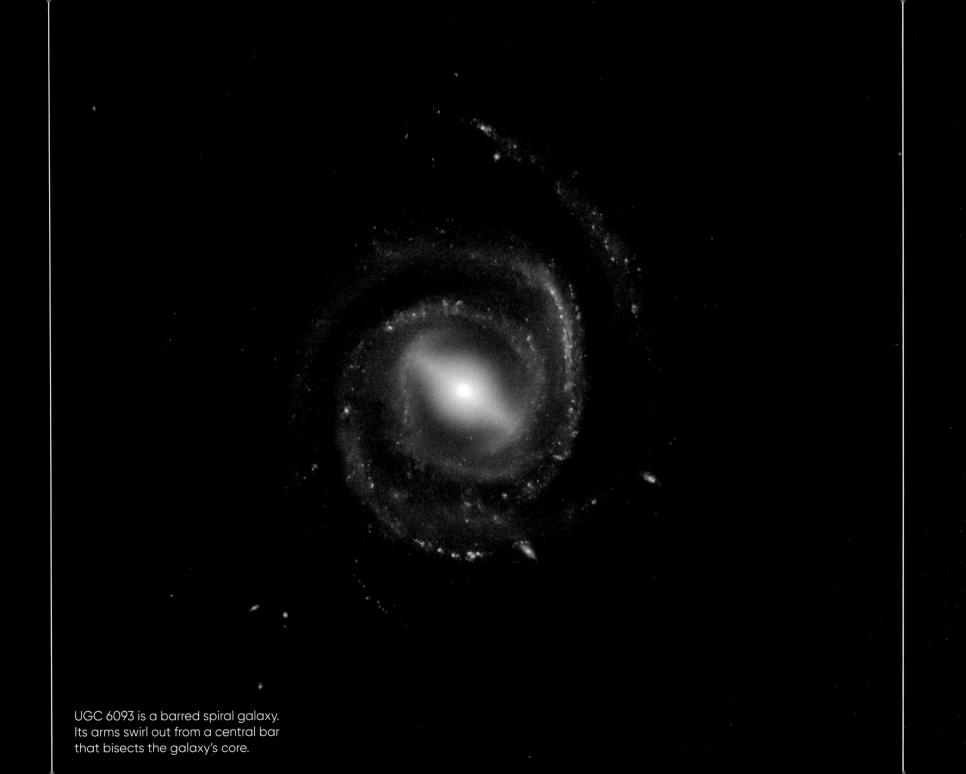

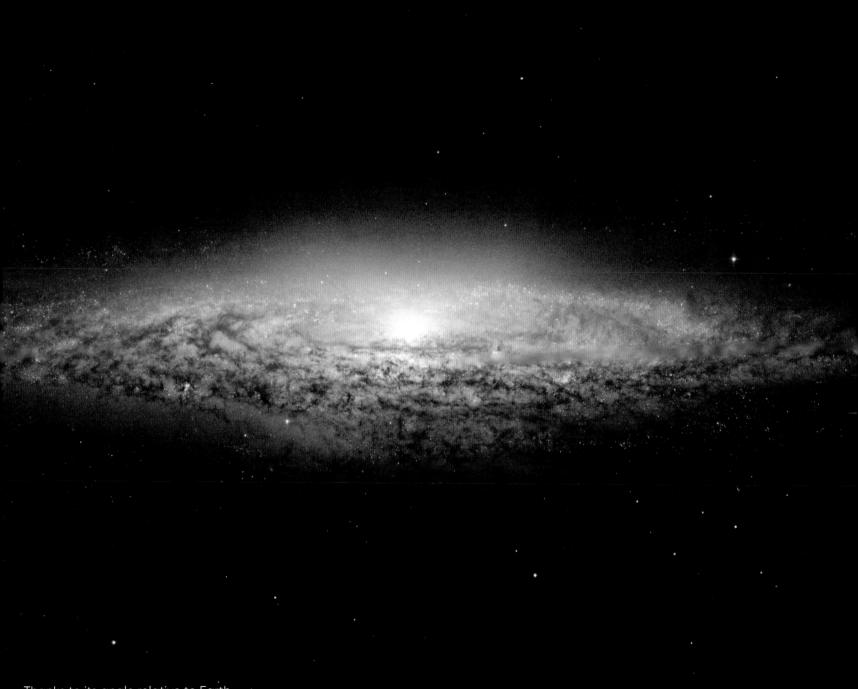

Thanks to its angle relative to Earth, we can see the intricate lanes of dust swirling around spiral galaxy NGC 2683.

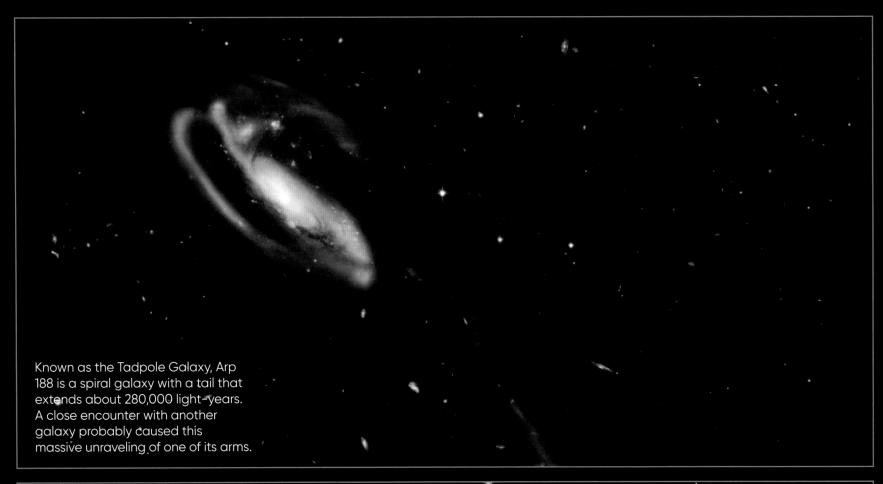

This dwarf irregular galaxy, known as PGC 18431, is part of our surrounding galactic neighborhood (the Local Group). This area of space contains about 50 galaxies.

NGC 1427A is an irregular galaxy about 20,000 lightyears in length. Another member of our Local Group, NGC 6822 is a dwarf irregular galaxy located only about 1.5 million light-years away.

These two colliding galaxies are known collectively as Arp 142.
While the galaxy at the bottom appears to retain its elliptical shape, the galaxy at the top was once a spiral, but has been stretched out of shape.

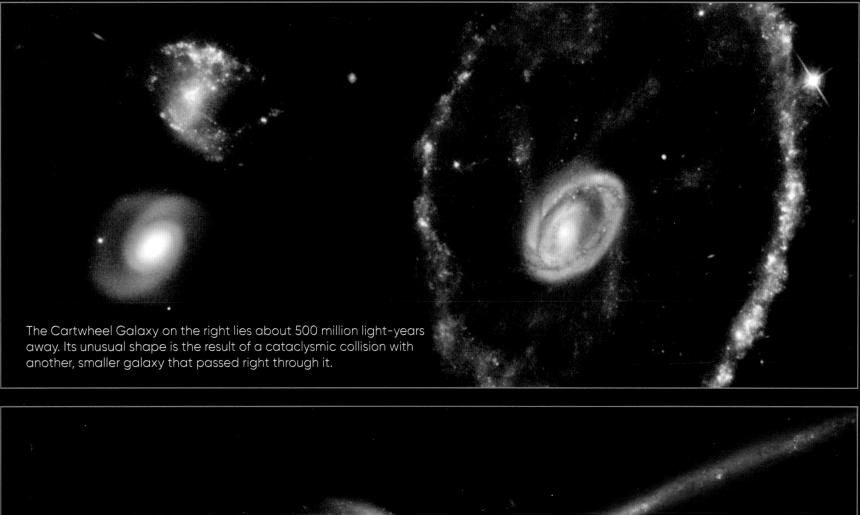

THE MANAGEMENT OF THE STATE OF

Our galaxy, the Milky Way, is a barred spiral galaxy. It may contain anywhere from 100 to 400 billion stars and stretches about 100,000 light-years across, though not all estimates agree. The central bulge has a diameter of about 12,000 light-years.

Our galaxy gained its name from the appearance it has in the night sky—a great milky band of light streaming across the sky. It wasn't until the early twentieth century that astronomer Harlow Shapley discovered this band of light was part of our celestial home. Our solar system is situated on the outer edge of one of its arms.

Looking directly into the heart of the Milky Way reveals a densely packed stellar neighborhood. The one thing we cannot see is the massive black hole at the center of it all.

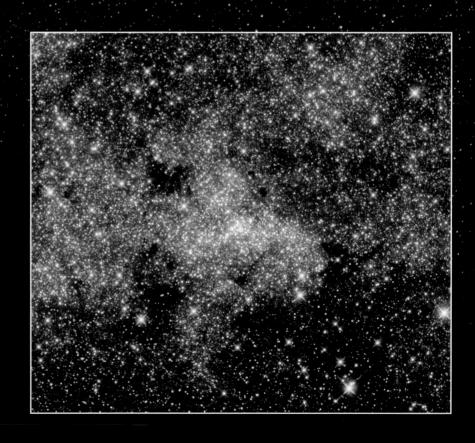

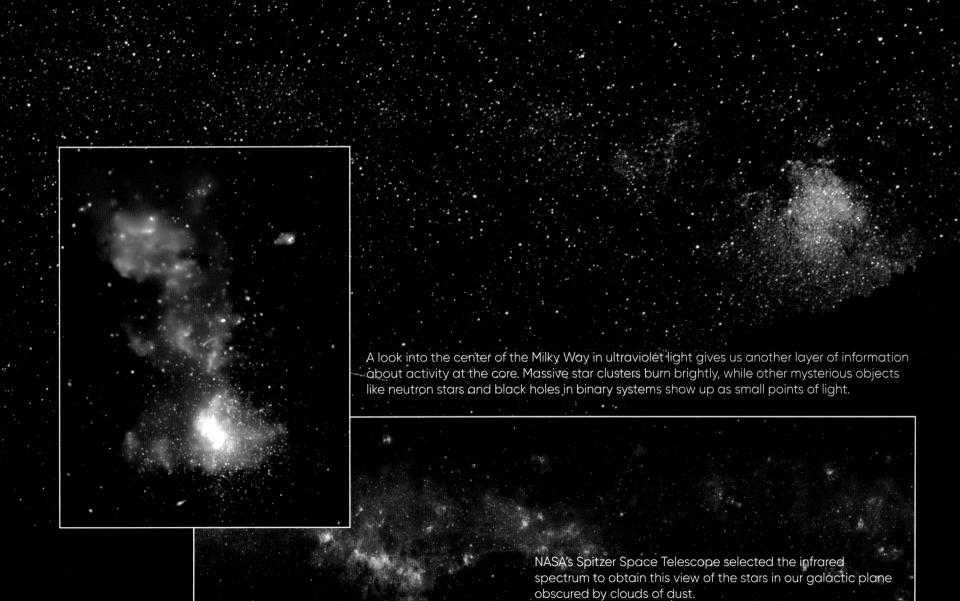

In the 1920s, astronomer Edwin Hubble determined that the Andromeda Galaxy was a separate galaxy beyond the Milky Way. Our closest large neighbor, Andromeda is about 2.5 million light-years away and about the same size as our galaxy. It will collide with our galaxy billions of years in the future. The collision will result in a new elliptical galaxy.